CATHY TAYLOR

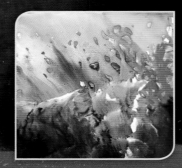

Pigments of Your Imagination
Creating with Alcohol Inks

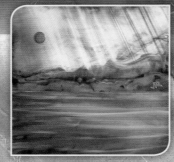

Schiffer
Publishing Ltd

4880 Lower Valley Road • Atglen, PA 19310

Other Schiffer Books on Related Subjects:

Earthen Pigments: Hand-Gathering & Using Natural Colors in Art.
Sandy Webster
978-0-7643-4178-6. $19.99

Library of Congress Control Number: 2014951910

Designed by Danielle D. Farmer
Cover Design by John Cheek
Photographs by Cathy Taylor
Type set in Dali/Museo Sans

ISBN: 978-0-7643-4753-5
Printed in China

Published by Schiffer Publishing, Ltd.
4880 Lower Valley Road
Atglen, PA 19310
Phone: (610) 593-1777; Fax: (610) 593-2002
E-mail: Info@schifferbooks.com

For our complete selection of fine books on this and related subjects, please visit our website at www.schifferbooks.com. You may also write for a free catalog.

This book may be purchased from the publisher. Please try your bookstore first.

We are always looking for people to write books on new and related subjects. If you have an idea for a book, please contact us at proposals@schifferbooks.com.

Schiffer Publishing's titles are available at special discounts for bulk purchases for sales promotions or premiums. Special editions, including personalized covers, corporate imprints, and excerpts can be created in large quantities for special needs. For more information, contact the publisher.

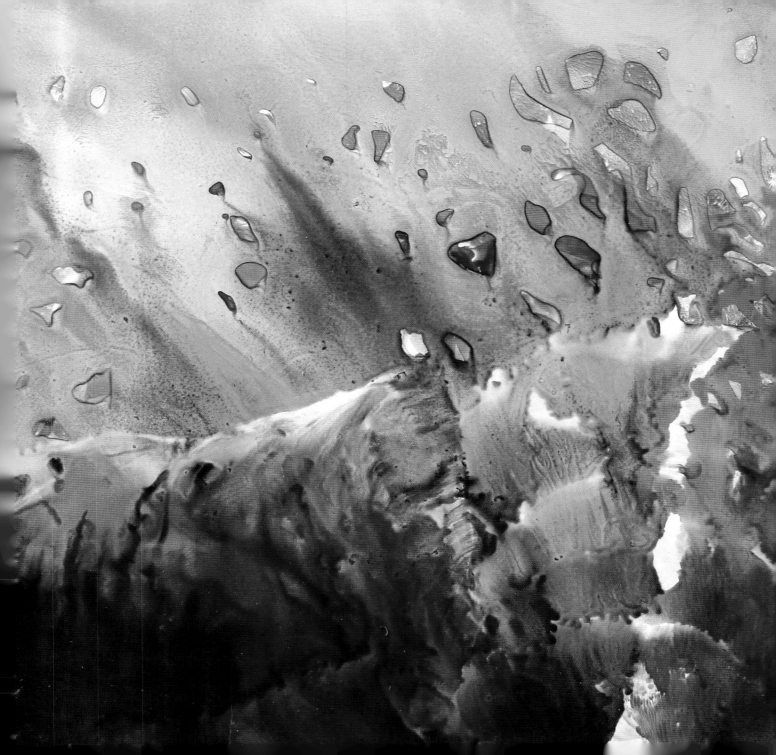

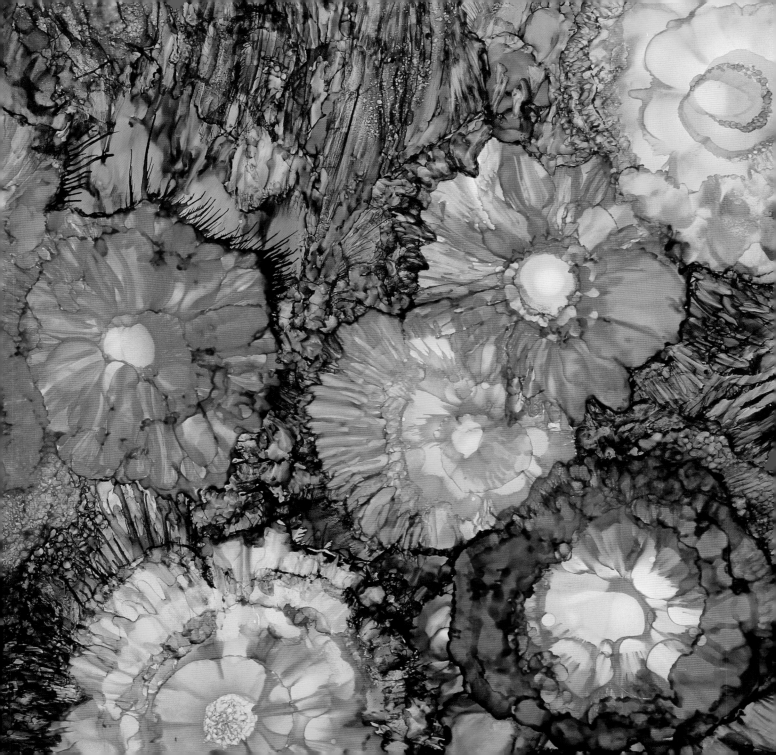

Contents

FOREWORD

How did alcohol inks make the leap from a crafting material to a fine art medium? Who was the person who looked at the inks and asked "what if?" What motivated this artist to create paintings with this medium rather than simply stamp with the inks?

With the help of some other alcohol ink pioneers, I found the artist who started the alcohol ink fine arts revolution. Sandy Scott, a lovely person and wonderful artist, is the one who discovered the potential of alcohol ink for creating fine art.

In 2006, Sandy and her niece visited a small art shop in New Bern, North Carolina, to purchase acrylic ink. The owner thought she might be interested in a new ink and introduced her to an alcohol-based ink. Fascinated by the intense colors, she began experimenting with their playful nature. Her original substrate was glossy photo paper. She then discovered the relatively new substrate called Yupo®, a synthetic watercolor paper. She began working to control this mindful medium, and the rest is history.

Her original work, *Tiny Village*, is alcohol ink-enhanced with ink pen. The second piece she created, *Chilly*, was accepted into the Centennial Art Show in 2007 and earned her second place. This exhibit was juried by the curator of contemporary art at the North Carolina Museum of Art in Raleigh who liked the abstract nature of the representational theme.

Sandy continued to explore the latitude of the inks, finding the spontaneity and color vibrancy intriguing. She soon graduated from a four by six format and has created works as large as thirty inches.

Sandy shared her new-found passion with fellow artist Karen Walker, who quickly discovered her own style combining a loose abstraction with very detailed precision. With excitement, information was passed along from artist to artist. Some taught classes and workshops introducing this exciting find. The more artists who experimented with alcohol inks, the more new ways of working with them evolved. I first tried the medium early in this discovery process and was immediately enchanted. I continue to discover new ways of working with this amazingly versatile medium.

Thanks, Sandy!

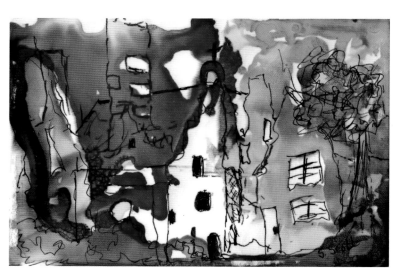

Tiny Village | Sandy Scott

INTRODUCTION

Welcome to the magical world of alcohol inks! Join me and my wonderful artsy friends on a journey of discoveries. Enjoy the process. Drip swirling colors, make mystic shapes, express your creative self.

"Inside you there's an artist you don't know about...say yes quickly if you know, if you've known it from before the beginning of the universe."

Rumi

All of us are artists in some way, and we can all discover our own unique talents through purposeful play and exploration.

As a child, I loved all things art and nature. I studied pottery with a neighbor, I sewed a quilt, I hooked a rug. Colored pencils were my affordable art makers. Dreams were collaged from old magazines. I collected shells, leaves, seed pods, flower petals, as well as my share of salamanders and minnows. My room was filled with terrariums, aquariums, leaf prints, and flower drawings.

In school, art was not considered a high priority and so I found myself immersed in the sciences—biology, geology, and chemistry. I graduated with a B.S. and entered the working world.

Vineyard | Cathy Taylor

It wasn't until sometime in my late twenties that I began to feel that something was missing. I was a successful business person, but my life lacked an artistic outlet.

"If I didn't start painting, I would have raised chickens."
Grandma Moses

I decided that in my limited spare time, I would dabble with watercolors. I bought a few tubes of watercolors, some brushes, and some paper. I wanted to paint real, lifelike images, just as Andrew Wyeth had. I studied all the technical aspects of creating a perfect watercolor painting. I practiced washes, dry brush, wet into wet, and all the techniques required to become a really good artist. I studied the principles and elements of design and compositional rules and formats. This was all very left-brained activity, and I did accomplish my goal. I could paint real things and they looked....real.

But, my paintings lacked a crucial component: ME. I am not by nature an exacting, methodical person. I am more of a "leap and the net will appear" type. I was not enjoying painting because it had become work. The reason I had started painting was for personal fulfillment and to enjoy creating something wonderful. So I began to color outside the lines, to bend the rules. So what if the end product was a swirl of colors and weird shapes? The process of creating and experimenting was fun; the magic had returned!

I began ripping up my weird experiments and creating collages. I added opaque white (Gasp!) to my transparent

Wild Bird Alphabet | Cathy Taylor

colors. I got some acrylics and some gels and gessoes. I realized that creating art is not about producing a product. Rather, it is all about the process. The aspect I was enjoying most were the "happy accidents," the unexpected discoveries.

I began to see things in a whole new way. I started to ask "what if"? (Now my favorite question, leading to only one studio evacuation.) What if I combined glue with acrylic, what if I used old coffee filters in a collage, what if I dropped salt into watercolors? I spent hours looking through art and craft stores, studying labels and looking at art supplies. My creations began to have life. The less I worried about the product and enjoyed the process, the easier the painting was created. The more I played, the more I learned. As a result, my work became better and better.

"I begin with an idea and then it becomes something else."
Pablo Picasso

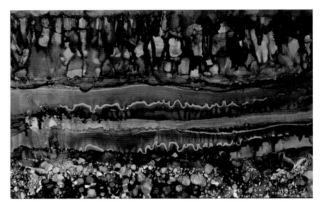

Lollypop Trees | Cathy Taylor

Electric Blue | Cathy Taylor

I began to see potential materials for creating art everywhere: old magazines, Styrofoam® food trays, dead appliances, cleaning products, old toothbrushes, computer parts, tea bags (minus tea), dryer sheets, waxed paper, plastic place mats, broken seashells, tree bark, and wasp nests (minus wasps).

I learned of a technique to alter old magazines, using an Earth-friendly cleaner, Citrasolv®, to create wonderful swirly, crazy papers for collage. The papers made magical collages, and as I played with them, I began to see shapes, figures, and trees. I thought, "what if" I painted onto the altered papers to bring out these interesting shapes. The papers resisted watercolor. Acrylic was too thick and opaque; ditto for oils. In an "ah ha" moment, I remembered some acrylic inks I had gotten years ago. Bingo, the inks were perfect.

Thus began my love affair with all things ink. I began to experiment with all types of ink. I found super-pigmented watercolor inks, dark India inks, different brands of acrylic inks, and weird iridescent

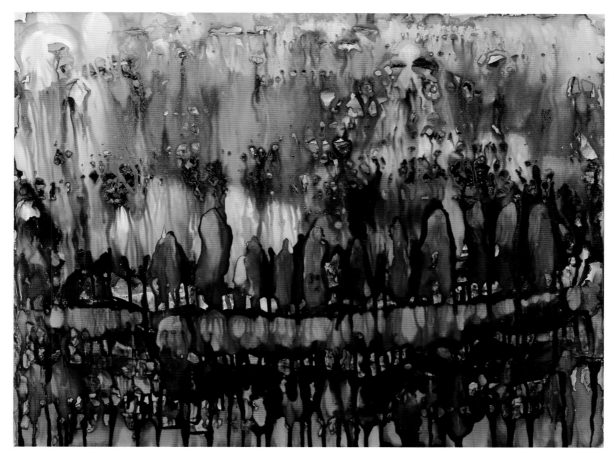

inks. There were ink pens, markers, and applicator pens. I discovered ink pads and re-inkers; and then something magical...alcohol inks.

This book is a journey of joyful experimentation. You will discover lots of different ways of working with alcohol inks on all sorts of surfaces. Mix and match, choose what you enjoy; what speaks to you. This book presents a mosaic of artistic adventures; there are no rules. Ask "what if." Try something new. Experience the pure joy of creating.

"Creativity is allowing yourself to make mistakes. Art is knowing which ones to keep."
Scott Adams

FINDING YOUR MUSE

As an artist, I find that I look at the world in a different and more intimate way. I see that trees are not green and the sky is not blue; shadows are not gray and the night is not black. Trees come in every shape and color and size, and even if they are green, they are many shades of green. The sky is constantly changing, creating endless combinations of shapes and colors. Shadows reflect the colors around them in mysterious and subtle ways. The night is full of nuances, sparkles, and outlines.

"Great art picks up where nature ends."

Marc Chagall

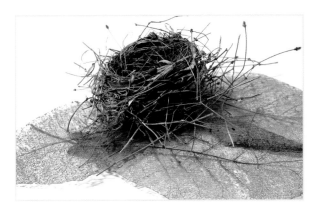

I found this bird's nest and skeleton leaves in the woods around my house. I loved the texture and patterns. I added them to my muse collection. The nest sits in my schefflera plant.

In my studio, I have collected objects and artifacts that speak to me in some way: Shimmering blue sea glass, an abandoned bird's nest, the workings of an ancient grandfather clock, spindles from an old weaving machine, leaf skeletons, a bright old paint palette too lumpy and beautiful to use, bits and pieces of exquisite fabric and thread.

I surround myself with things that invite inquiry, things that ignite my curiosity and awaken my creative senses. Even if your art space is small, you can find tiny gems to jump-start your creativity. Keep a collection of photos, images, and admired artwork to flip through when you need a creative boost.

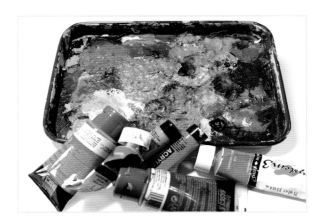

I used this metal palette when I painted with acrylics. One day I looked at this beautiful dried mess and declared it a finished painting.

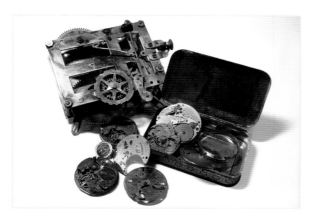

I fill my studio with things that inspire me, and each time I enter my special sacred space, something will catch my eye and challenge me to open myself to creative observation and the joyful process of translation. I am not concerned with copying the likeness of something, but rather expressing through my art the essence of the subject and the feelings that are generated. How best to capture the explosion of color that is a lily blossom; how to paint the symmetrical spiral of a seashell?

My father was a watch maker, and I have developed an affinity for watch and clock parts. I love all of the little gears and moving parts.

Alcohol inks have provided me with a whole new avenue for expression. Each color has its own personality and gaining an understanding of the interaction between the inks is a fascinating and surprising journey. Surround yourself with things that delight you and enjoy the pure process of creating. You'll be surprised at what you can do!

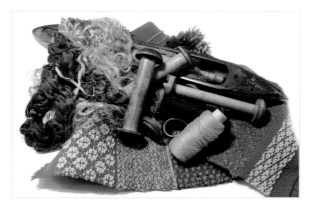

The only art class I took in college was a loom weaving class. I spent every moment of my spare time in that studio. The gorgeous colored threads and the rhythm of the fabric were enchanting.

"Discovery consists of seeing what everybody has seen and thinking what nobody has thought."

Albert Szent

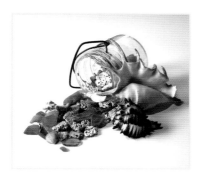

Turn me loose on a beach and I will walk for miles collecting bits of beach stuff. I especially like the muted, pastel beach glass that tumbles on shore.

MATERIALS AND TOOLS

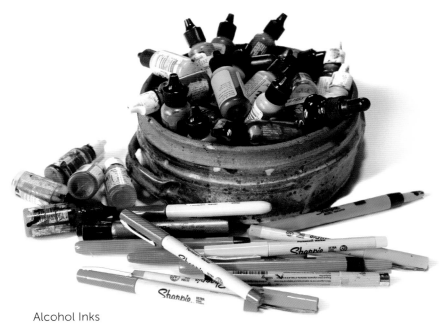

Alcohol Inks

"To invent, you need a good imagination and a pile of junk."
Thomas A. Edison

— Substrates —

Bristol paper

Yupo® paper

Canvas or canvas paper

Claybord™

Glass

Waxed paper

Plastic

Fabric

Ceramic tile

Metal

Plexiglas®

Terraskin® paper

Found objects:
 washers, dominoes,
 beverage cans

— Colors —

Piñãta® alcohol inks

Ranger Adirondack®
alcohol inks

Spectrum Noir™ re-inkers

Copic® re-inkers

Sharpie® pens

Copic® markers

Spectrum Noir™
markers

Pigma® pens

— Adhesives and Mediums —

White glue

Acrylic matte gel medium

Acrylic gloss medium
and varnish

Tar gel

Plaid® faux stained-
glass leading

91% rubbing alcohol

Krylon® spray varnish

Masking fluid

Gloves in a Bottle®

Fabric paste

Ranger Adirondack®
Blending Solution

Jacquard® Piñata Claro
Extender

Hand sanitizer

— Tools to Create With —

Watercolor brushes,
synthetic, round

Hake brush

Palette knife

Felt

Craft foam

Stencils and stamps

Toothbrush

Drinking straws

Coffee stirrers

Old credit card

Makeup sponges

Plastic placemats

Laminate

Contact paper

Craft knife

Scissors

Old cookie tray

Styrofoam produce trays

Cotton swabs

Oiler boiler

Hair dryer

Canned air

ABOUT ALCOHOL INKS

Unpredictable, wildly colorful, vibrant, fascinating alcohol inks! A relatively new art medium, alcohol inks can be used to create glowing paintings, gorgeous ceramic tiles, marbled fabric, faux stained glass, and more! Alcohol inks are formulated for use on nonporous surfaces, including metal, plastic, Plexiglas, glass, and slick paper such as Yupo. The colors have differing properties when interacting with each other, allowing for interesting effects such as resisting and blending.

Working with alcohol ink is different than working with oil, acrylic, or watercolor paint. The inks are super bright, fluid, and highly interactive. They may be used full strength for an intense burst of color or diluted for a subtle look similar to a soft watercolor wash. They may be painted, dropped, dripped, drawn, stamped, or spattered.

The colors are intermixable, fluid, and lightfast. Alcohol inks dry quickly and are fairly inexpensive compared to other mediums. They may be used with other products such as acrylic gel medium, acrylic varnish, tar gel, or white glue to create special effects. Several different brands are available at art and craft stores or online.

Adirondack alcohol inks by Ranger are fast drying, acid free, and fade resistant. They come in one-half-fluid-ounce bottles with precision tips. Forty-eight colors from brights to earth tones to lights are available. You may also want to try pearl, white, and metallic mixatives.

Piñata inks by Jacquard are beautiful, highly saturated, acid-free colors. They are indelible and moisture resistant when dry, They are available in twenty-one different colors including gold and silver, which are formulated with real metal. The tiny particles produce highly reflective and interactive effects. Piñata inks come in one-half-fluid-ounce bottles with tips, or four-fluid-ounce bottles with caps.

Spectrum Noir makes re-inkers for their alcohol-based markers. Re-inkers are available in 168 colors. The one-half-fluid-ounce bottles come with an eye-dropper cap.

Copic marker re-inkers are available in 358 colors. They are also acid free, fade resistant, and fast drying.

Alcohol-based ink pens, markers, and pads are also available in a myriad of colors. Brands include Micron, Pigma, Copic, Sharpie, and Spectrum Noir.

Solutions are available for assisting in blending and manipulating the inks. The most aggressive solution is 91% rubbing alcohol, which is available at your pharmacy. It will quickly lighten the inks and dull the shine to a more matte finish. Ranger Blending Solution contains alcohol but also contains glycol; it lightens and moves the inks less than rubbing alcohol but also tends to leave a more matte finish. Piñata Claro gently lightens the inks and maintains their gloss.

Experiment mixing brands, colors, and applications. Develop your own personal palette with your favorite colors and brands. The possibilities are endless!

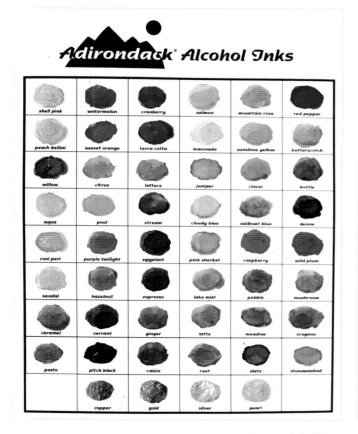

Ranger Ink Chart

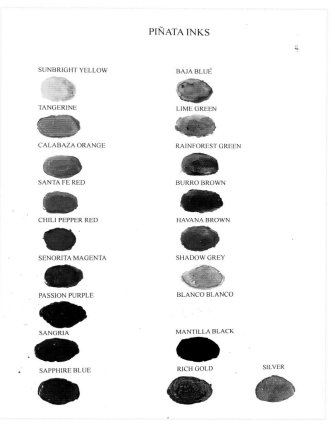

Piñata Ink Chart

Alcohol ink may be used on a wide variety of substrates, many of which are discussed in Chapter 6. For the purpose of continuity, alcohol ink will be demonstrated on Yupo paper unless otherwise indicated.

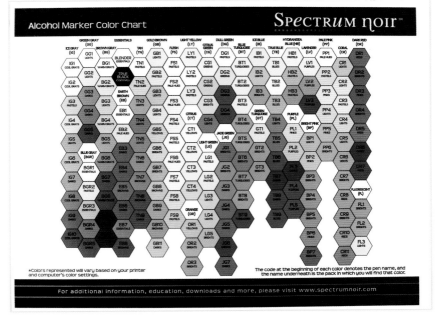

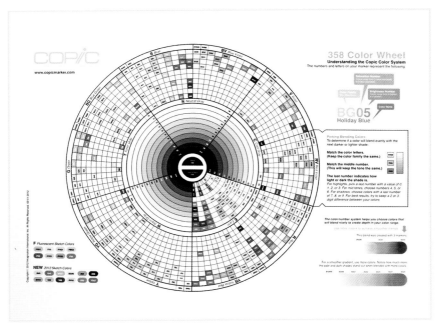

Simply Start

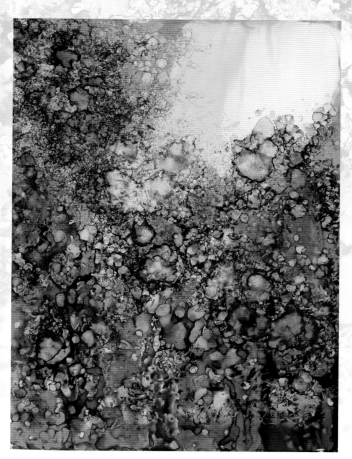

Cascade | Alexis Bonavitacola

As a water media artist, I know a fair amount about colors, substrates, paint brushes, and a variety of mediums. When I began working with alcohol inks, it became instantly clear that these inks were an entirely different animal. They are not water based, they are not polymer based, and they are not oil paints. Though yellow and blue usually make some sort of green, the individual properties of the inks change the rules. For instance, Stonewashed is blue, but drop it on a substrate and it will form a pink aura. Place alcohol inks in a palette and presto, they evaporate. Paint them onto watercolor paper, and they soak in as dull and dry as mud.

So how does one go about learning all the new rules, and discovering what alcohol inks can do? Simply start! Begin with simple, easy techniques that allow for playful discovery and accidental masterpieces.

In this chapter, you will find simple techniques for working with alcohol inks. They are presented one method at a time, step by step, allowing you to discover how colors react, blend, and invade other colors. As you become familiar with the colors and types of ink, these techniques can be combined to create beautiful artwork that will surprise and enchant the viewer.

- Alcohol inks
- Felt
- Yupo paper
- 91% rubbing alcohol

- Drinking straw
- Craft foam
- Toothbrush
- Old credit card

- Hand sanitizer
- White glue
- Cotton swabs
- Paper towels

Enjoy the process as we begin the journey. Simply start!

"Every child is an artist. The problem is to remain an artist once he grows up."

Pablo Picasso

TEXTURE WITH FELT STAMPING

Applying alcohol inks with felt creates a wonderful marbled texture. When you layer different colors, the inks react with each other in interesting and surprising ways. I use this technique to create wonderful backgrounds to paint into, or I use the colorful papers for magical collages.

1 Apply several drops of ink to a piece of felt. Stamp the felt over the surface of the Yupo paper.

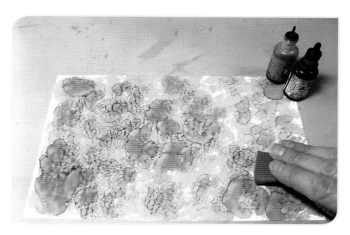

2 On a clean piece of felt, apply another color and stamp over the first layer.

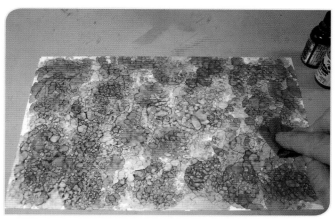

3 Continue adding colors for a marbled effect.

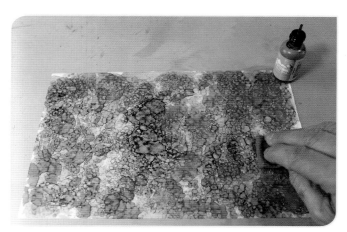

4 With a clean piece of felt, stamp alcohol into the colors to lighten.

Felt applicator tools are available at craft stores or online, or you can make your own by gluing a piece of Velcro® to the bottom of a piece of wood, such as the back of an old stamp. A nifty new product called Blendall™ is a double-sided round blender that prevents hard lines.

DISCOVERING INK DROPS

Experiment by dropping colors of inks onto a sheet of Yupo paper. Drop one color into another, and notice how each color reacts to the other. Some colors such as the Ranger lights will move other colors away. Other colors such as Ranger Stonewashed blue will form an aura of another color around the edge, in this case pink. Simply dropping inks onto the paper and watching as they mix is a fabulous way to learn the individual properties of each color and type of ink. You can also produce delightful, playful abstract images of bubbles and balloons!

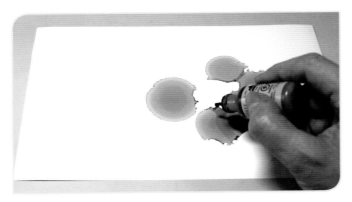

1 Start by dropping colors of ink onto a sheet of Yupo paper.

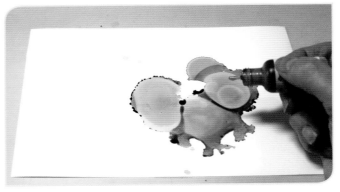

2 As you add a new color, see how it reacts to the first color.

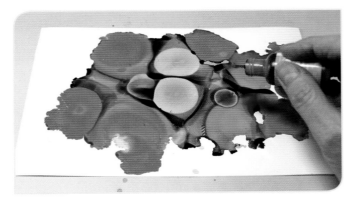

3 Some colors, such as the Ranger lights, will move other colors away.

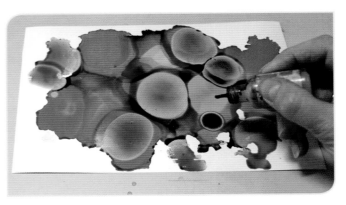

4 Other colors will form an aura of another color around the edge. Ranger Stonewashed blue, for example, forms a pink.

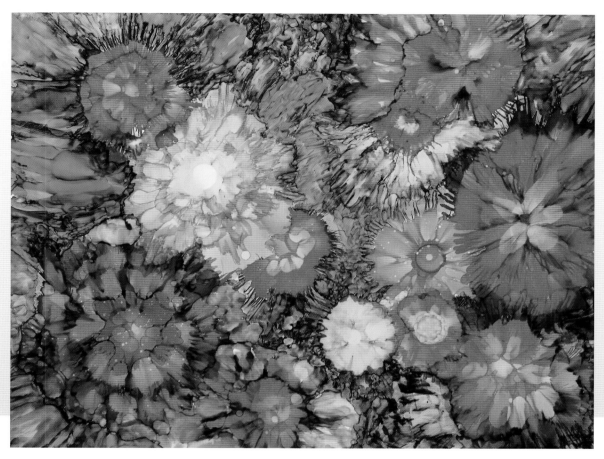

BLOWING INKS TO
CREATE SHAPES

To achieve a floral shape, squeeze a couple drops of ink onto the Yupo paper and immediately blow the ink with a straw. The ink will move according to how hard you blow, how close the end of the straw is to the ink, and the angle at which you blow. Manipulating inks by blowing them with a straw is a lot of fun. If you blow straight down onto a drop of ink, a floral burst will occur. Blow at an angle, and a leaf or stem shape emerges. Puff quickly into the center of an ink drop, and the ink will expand and then fall back into itself, creating a lovely center outline.

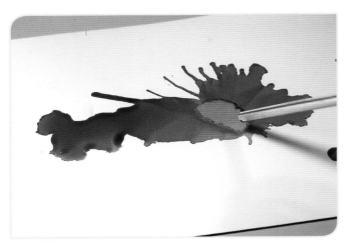

1 Start your floral shape by squeezing a couple drops of ink onto Yupo paper and then immediately blowing the ink with a straw.

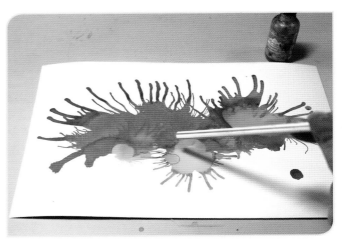

2 Experiment with moving the ink by changing how hard you blow, how close the end of the straw is to the ink, and the angle of the straw.

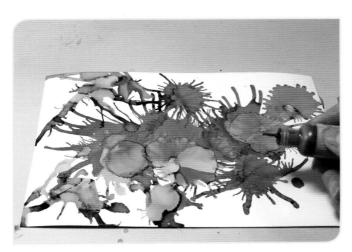

3 Add colors and overlap shapes.

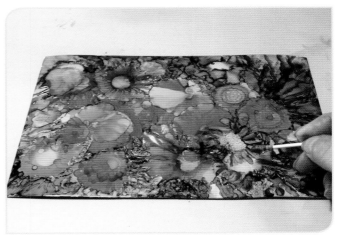

4 Squirt ink onto a cotton swab, and dab green foliage around the flowers.

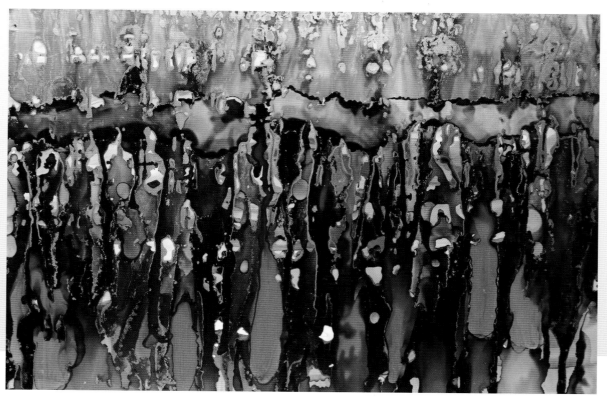

CREATING WITH DRIPS

Creating with alcohol inks is mesmerizing and very entertaining. Simply dripping inks onto the paper and guiding their movement by tilting the paper creates beautiful effects. Piñata Gold is particularly amazing when dripped into other inks.

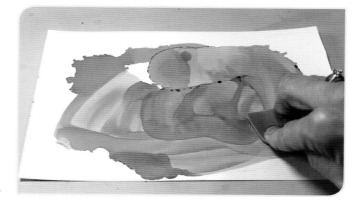

1 With felt, blend colors over a sheet of Yupo paper.

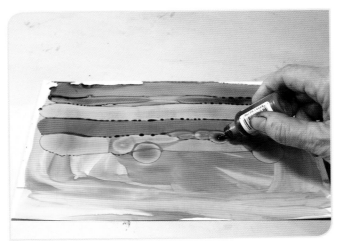

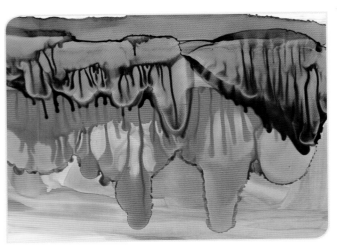

2 While the paper is flat, squirt lines of different colors horizontally across the paper, starting at the top and working half way down the paper.

3 Tilt the paper at an angle, allowing the colors to drip and mix. Control the drip by tilting the paper in different directions. It is helpful to place the Yupo on a piece of cardboard or other stiff surface. Add other colors as you tilt the paper. You may add drips or spatters. Continue allowing colors to drip and blend.

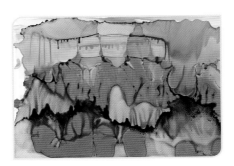

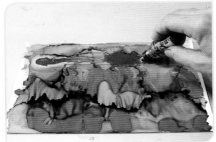

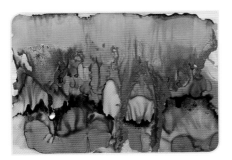

4 Turn the Yupo upside down and reverse the process. You may also add drops of rubbing alcohol to help colors mix and move.

5 Add a line of Piñata Gold towards the top of the paper. Above that line, add one of the Ranger lights, such as Lemonade, Mountain Rose, Peach Bellini, or Stonewashed.

6 Tilt the paper at an angle and watch magic happen. Continue to tilt the paper until you achieve a design that you like.

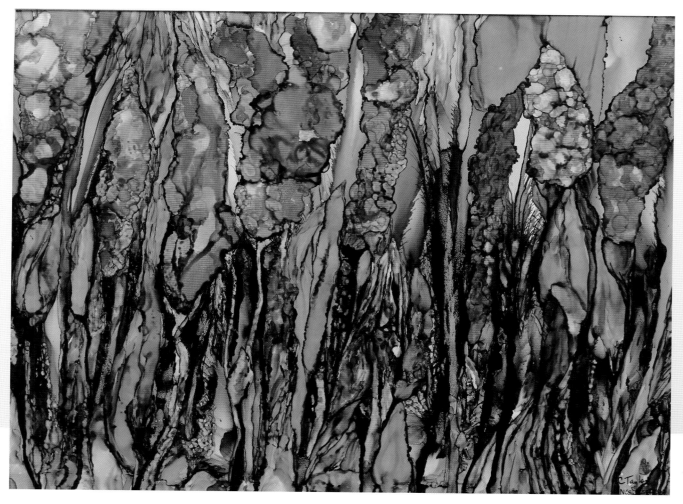

DRIP AND BLOW TEXTURE

Add another dimension to your paintings by combining drips of ink and blowing inks. I use this technique to create abstracted grasses and leaves. I love the tiny fine lines and textures that are created.

27

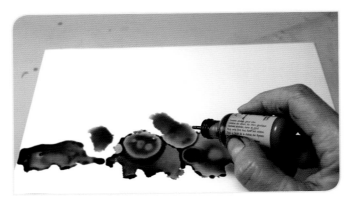

1 Place several drops of ink onto a sheet of Yupo paper.

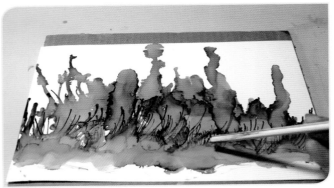

2 Hold the paper at an angle and blow the drops down the Yupo.

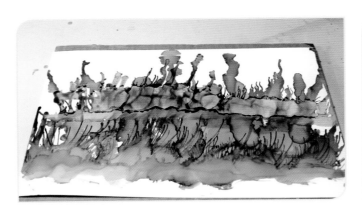

3 Continue to add drops and blow from the top of the tilted paper to the bottom. Keep adding drips of different colors and blowing to create grassy shapes.

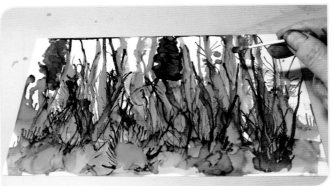

4 Dab in flower shapes with cotton swabs squirted with different colors.

CRAFT FOAM PAINTING

Who would have thought that a simple piece of inexpensive craft foam would be the perfect tool for moving alcohol ink around a surface? In a "what if" moment, I took a piece of craft foam and began to manipulate the ink on the surface. The craft foam enabled me to move the inks much easier than using a brush. You can even create fine lines and marks.

1 Cut a sheet of craft foam into small squares.

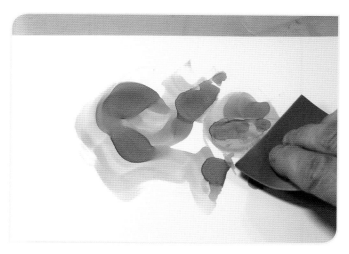

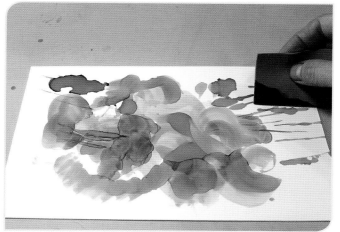

2 Squirt some ink onto a sheet of Yupo paper. Using the foam square, push and pull the ink around the paper.

3 Squirt ink onto the edge of the foam and then stamp to create fine lines and marks.

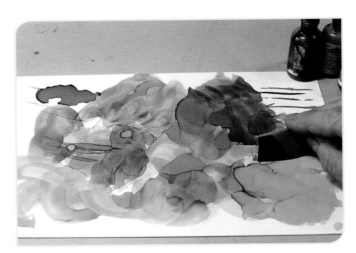

4 Blend colors together. Create swirls and shapes with the foam.

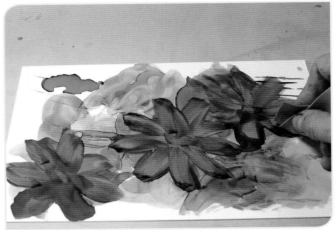

5 Use the corner of the foam to pull out shapes such as flower petals.

"A painting is what you make of it; besides which "Moon Weeping" has a better ring to it than "Paint Brush Dripping."

Robert Brandt

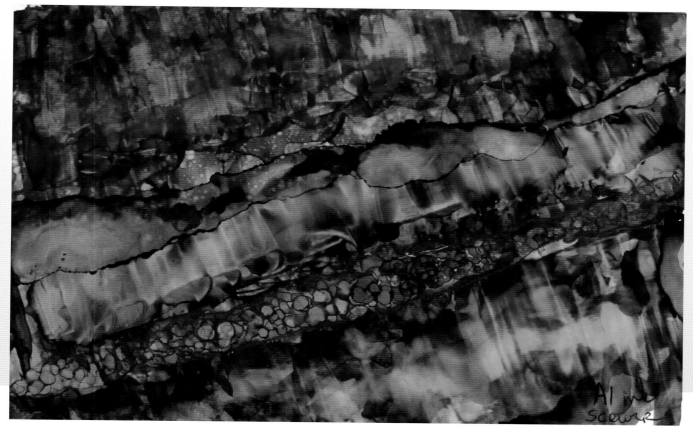

USING A STRAW TO CREATE PASSAGES

Drinking straws are terrific for blowing shapes, but they can also be used for guiding inks around the surface. The side of the plastic straw is smooth and slightly bendable. It is the perfect tool for moving inks around the paper. I find it exciting when such a simple, inexpensive tool can create such amazing effects!

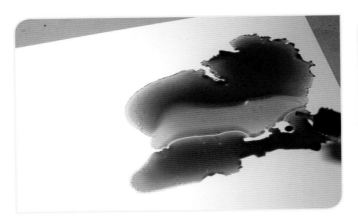

1 Run some lines of color across the Yupo paper.

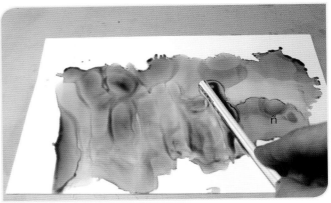

2 Using the side of the straw, gently move the inks across the paper.

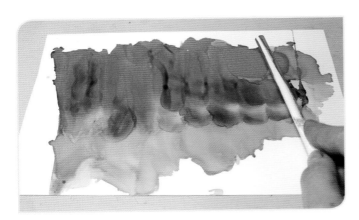

3 Create "ribbons" of color by undulating the straw.

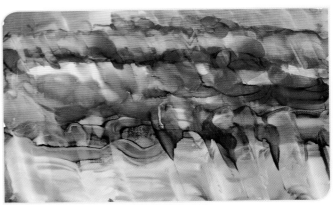

4 Add detail with a brush or pen.

TOOTHBRUSH TEXTURE

Another simple household tool that I use to create interesting effects is an old toothbrush. Spattering ink or alcohol onto a painted surface will create misty back-runs and sparkly highlights. When spattering, protect any areas of your painting that you wish to protect with a paper towel. Spatters have a way of going everywhere!

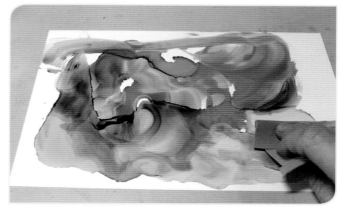

1 Apply inks to a sheet of Yupo paper using a craft foam square.

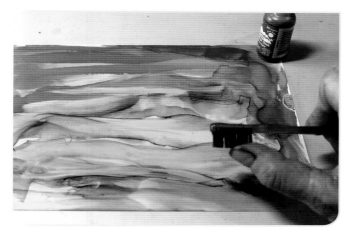

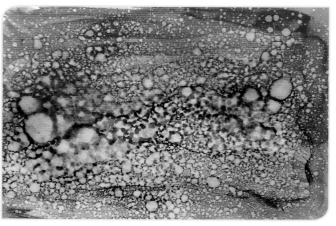

2 Drop another color of ink onto an old toothbrush. With your thumb, spatter the ink onto the paper to create a bubbly texture.

3 Use plain rubbing alcohol on a toothbrush to create white spots.

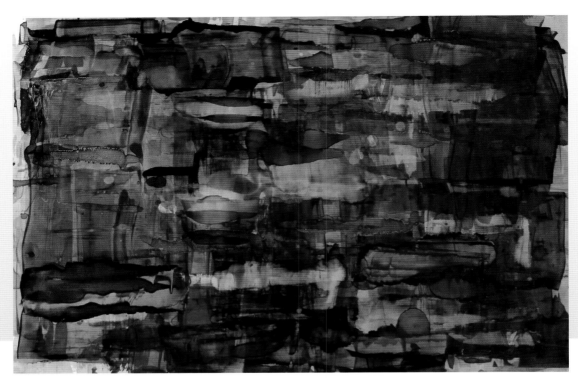

SCRAPE A DESIGN WITH A CREDIT CARD

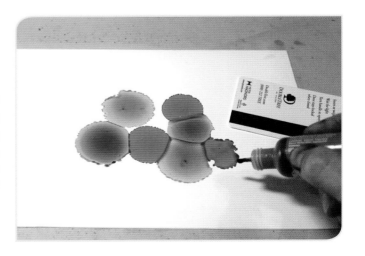

Art supplies can be expensive. I have a collection of brushes, pigments, and papers that I have collected over the years, many of which sit idle. So, I love finding tools that are inexpensive or free. Old credit cards have been used by artists since the cards were invented. When they are used with alcohol inks, the effects are can be particularly enchanting.

1 Place several drops or lines of ink onto the Yupo.

2 Use an old credit card to drag the inks into shapes.

3 Repeat the process and allow the inks to blend.

You may leave bottles uncapped while working.

GLUE TEXTURES

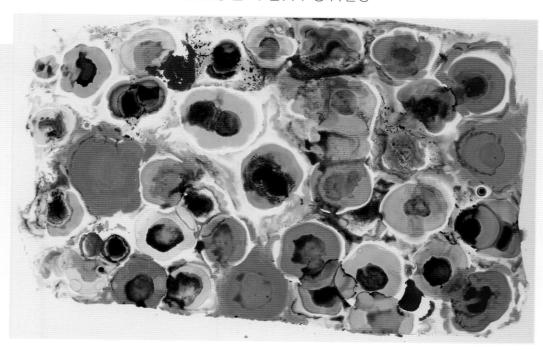

Potpourri | Cathy Taylor

Alcohol ink reacts to various substrates in different ways. Create an amazing effect with white glue mixed with just a touch of water. Paint a substrate with the glue mixture. Make sure it is nice and gloppy. Then drop inks into the glop. Try lots of different colors. Some will explode, some will granulate, and some will form weird shapes. What a happy thing to play and create.

1 Brush glue mixture (⅞ glue and ⅛ water) onto a sheet of Yupo paper with a hake brush.

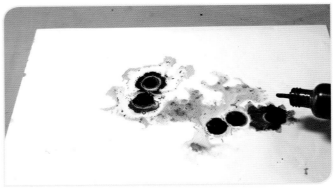

2 Drop inks into the glue mixture. Colors such as Stream will burst into particles.

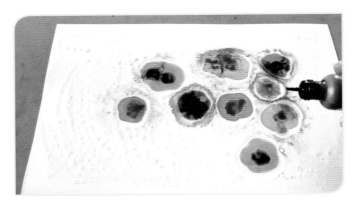

3 Continue to add colors, and watch how each reacts.

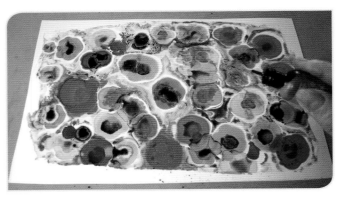

4 Allow the ink glue spots to dry overnight. Enjoy as a playful abstract, or work back into the painting.

CREATING TEXTURES WITH HAND SANITIZER

What If? Hand sanitizer is alcohol based. So what if we coat a piece of Yupo with some hand sanitizer and then drop in alcohol inks? Different weird shapes and textures occur. Some inks separate, and others bloom.

1 Squirt hand sanitizer onto Yupo paper.

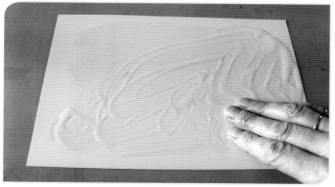

2 Spread and swirl the hand sanitizer with your fingers.

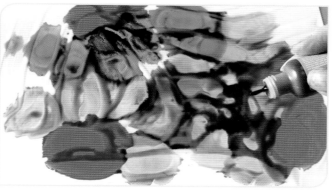

3 Drop various colors of inks onto the Yupo.

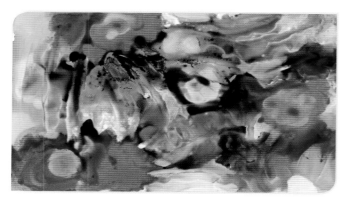

4 The inks will react in weird and wonderful ways. Allow the piece to dry.

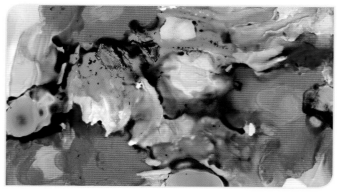

5 Enjoy the piece as a playful abstract, a background for an ink drawing, or work back into it with inks and rubbing alcohol.

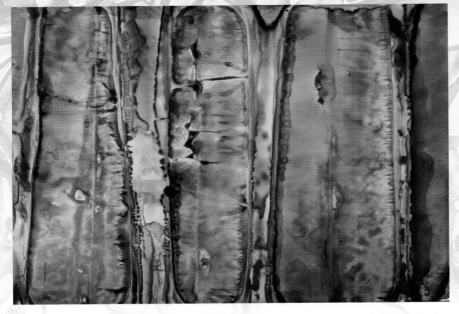

Amber Fossil | Cathy Taylor

Wow, with all the fantastic, amazing, wild things we discovered about alcohol inks in Chapter 1, what are the special effects that can be achieved? I have been working with alcohol inks for some time, and I am still amazed and surprised by the latitude of this medium.

By adding some simple materials to the mix, alcohol inks take on a new dimension. As in Chapter 1, once these techniques are mastered, they can be combined with other techniques, mixed and matched, to create stunning visual effects. Purposeful play is the secret to successful experimentation.

"Creative ideas can be sparked by having constant awareness of seeing situations and objects from an original, unconventional viewpoint."

Guy Lipscomb

- Alcohol inks
- Waxed paper
- Yupo paper
- Craft foam
- Stencils
- Alcohol pens and markers

- Acrylic gel medium
- Palette knife
- Old credit card
- Small round watercolor paint brush
- Tar gel

- Laminate or contact paper
- Masking fluid
- Paper towels
- 91% rubbing alcohol
- Plastic wrap
- Terraskin paper

WAXED PAPER TEXTURES

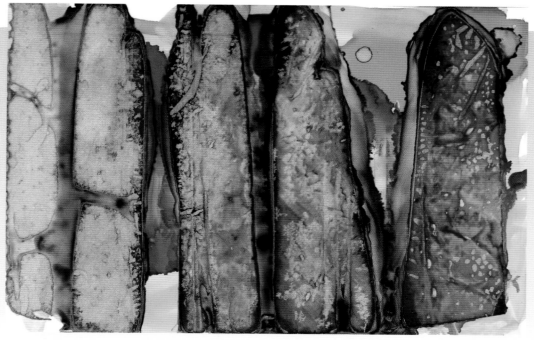

Totem | Cathy Taylor

I have used waxed paper in the past to create cool textures and shapes with watercolors. Small bits placed into wet pigment and allowed to dry create rock-like images. Crunched waxed paper creates a mosaic effect. So when I began working with alcohol inks, I wanted to see what type of effects I could achieve using waxed paper. As I suspected, pieces of waxed paper placed into the ink created rock-like textures, which were nice. But when I decided to fan-fold a sheet of waxed paper and place it into the wet inks, the effect was phenomenal.

1 Fan-fold a sheet of waxed paper.

2 Apply several colors of ink to a sheet of Yupo paper with a craft foam square.

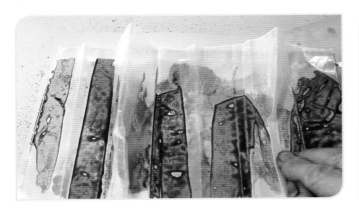

3 Squirt several lines of ink onto the Yupo, and immediately apply the fan-folded wax paper.

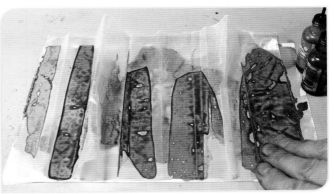

4 Press the folds into the ink.

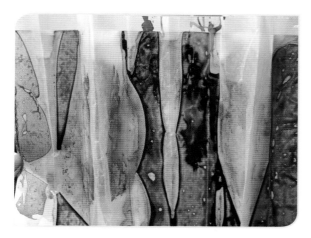

5 Tilt the paper at an angle and squirt another color of ink under the waxed paper folds. Allow the ink to drip down under the waxed paper.

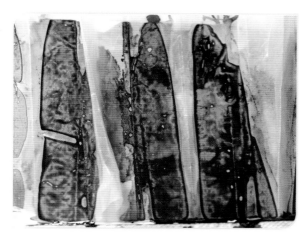

6 Allow the painting to dry. When the paper is dry, remove the waxed paper to reveal a lovely variegated design. Enjoy as a finished painting, or cut the design to make a collage.

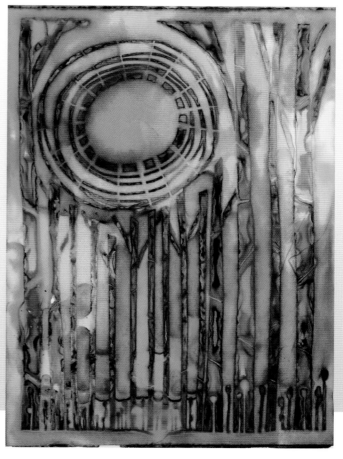

WORKING WITH STENCILS

Using stencils is a great way to introduce new and interesting shapes and textures to your work. There are a vast array of stencils available in all shapes and styles, or you can make your own by cutting a design into a plastic placemat with a craft knife. When I use stencils, I like to use parts of the stencil combined with other stencils to create my own unique design.

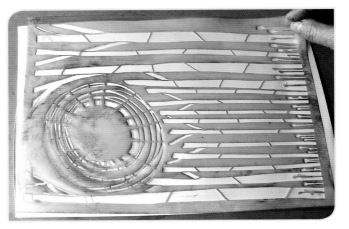

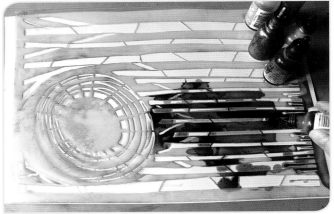

1 Place a stencil onto a sheet of Terraskin paper.

2 Generously apply alcohol inks to the spaces in the stencil. Allow the inks to run underneath the stencil.

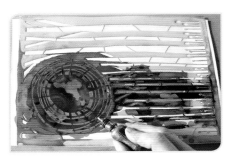

3 Continue to generously apply different colors of alcohol ink.

4 Make sure the colors move under the entire stencil. Squirt more ink into areas where there are bubbles.

5 Allow the ink to dry, and remove the stencil.

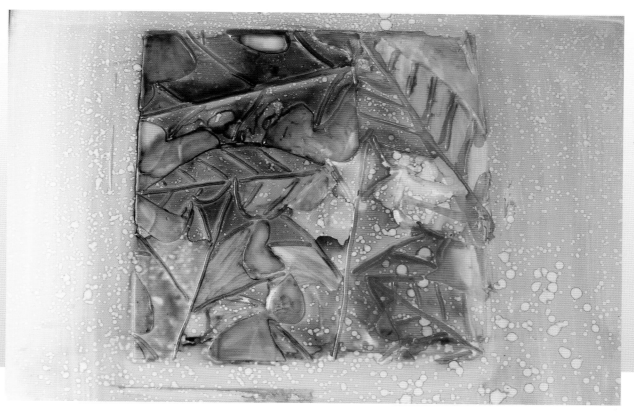

CREATING STENCIL DESIGNS WITH GELS AND PASTE

Gel medium is a very useful, versatile acrylic It is a terrific glue, able to hold odd-shaped or heavy objects in a collage. It may also be used to create a textured ground or background on your surface. When used with a stencil, gel medium will allow you to introduce interesting shapes to the mix. You may also use fabric paste for a different texture.

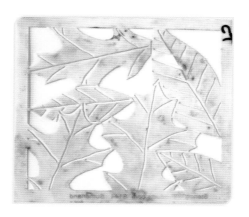

1 Place a stencil onto a sheet of Yupo paper.

43

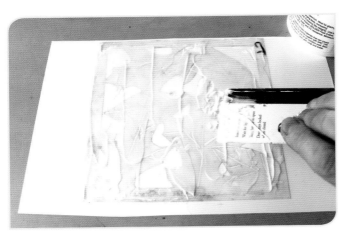

2 While holding the stencil in place, use the palette knife or old credit card to apply gel medium or fabric paste across the stencil.

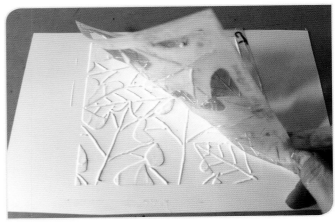

3 Scrape off the excess gel or paste, remove stencil, and allow the gel/paste to dry.

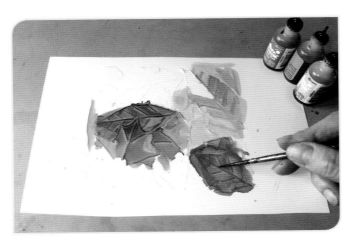

4 Drop inks onto the Yupo and move around the paper by dripping, applying with craft foam, or brushing with a small brush.

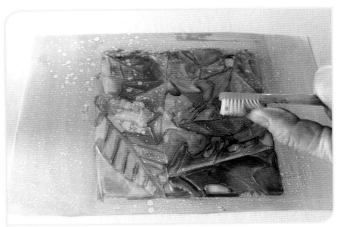

5 Continue adding colors. For a little punch, add Piñata Gold, or spatter with alcohol.

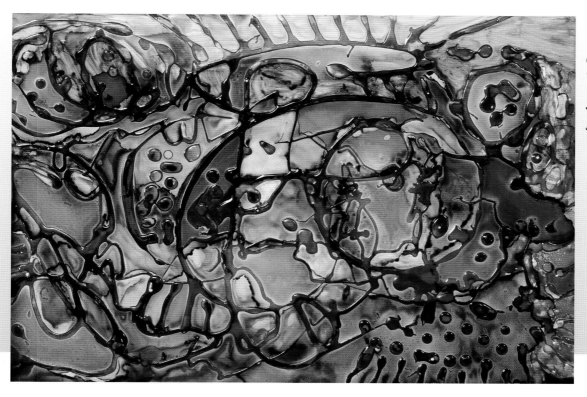

DESIGNING WITH TAR GEL

Tar gel, or string gel, is a super-fun medium. The gel is an extremely runny acrylic polymer. When it is dripped, it flows in a continuous and consistent line. When it is dripped onto a surface and allowed to dry, you can paint into it, drip inks, or blow inks to create back-runs and other cool effects!

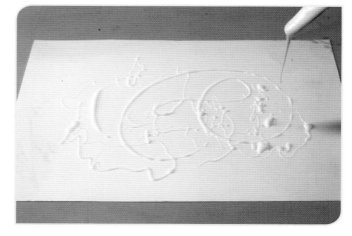

1 Have fun drizzling tar gel onto a sheet of Yupo paper with the end of a palette knife or coffee stirrer. Create a fun design, or write something.

45

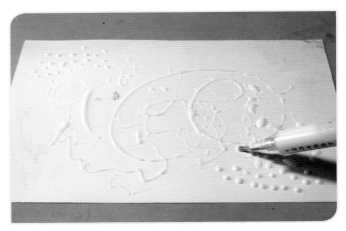

2 Or, use a syringe, minus needle, filled with tar gel to create fine lines or dots.

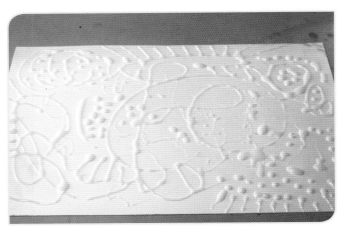

3 Allow the tar gel to dry completely.

4 Gently squeeze inks onto a small round brush and paint into the raised design.

5 Add inks and lighten with rubbing alcohol until you have a design you enjoy.

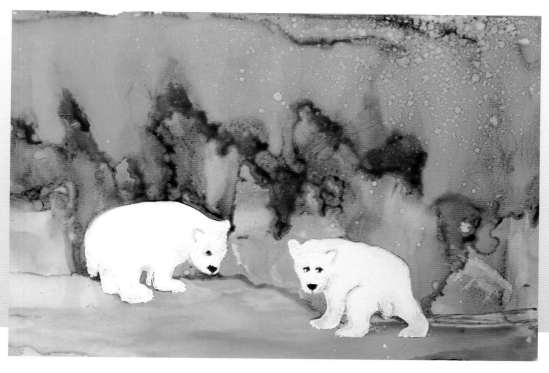

RESERVING SHAPES WITH LAMINATE

Plastic stick-on laminate is a great tool for reserving white areas or underlying shapes in your paintings. You can find clear laminate in sheets or rolls at an office supply store or home improvement store. It is inexpensive and easy to use. And there is a bonus! After you have used the laminate to preserve areas, remove the laminate that is now covered with inks, and save it to use in a future collage.

1 Using a marker, draw shapes onto the laminate. I am using a traced image from Dover Publications as a template.

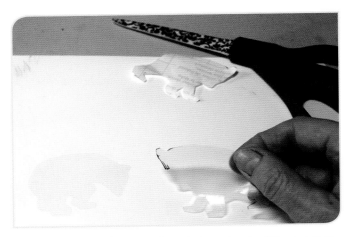

2 Cut laminate, and apply to a sheet of Yupo paper to reserve white shapes.

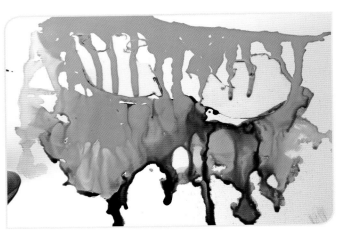

3 Apply inks over the paper by dripping and guiding the inks with a coffee stirrer or straw.

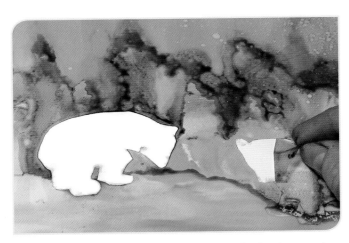

4 When you have achieved the color background you like, remove the contact paper.

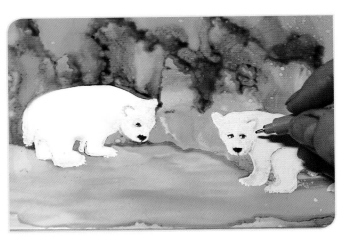

5 Enhance the shapes with alcohol pens or inks.

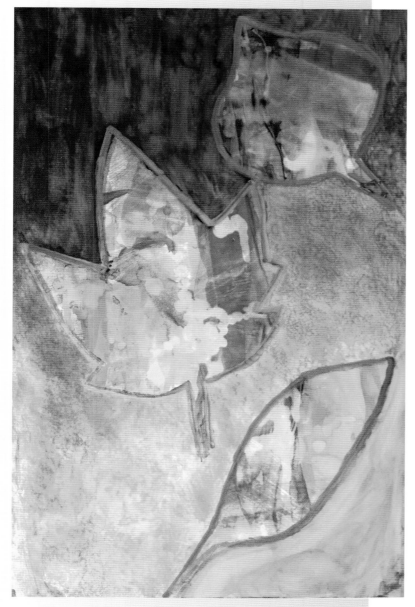

Trio | Cathy Taylor

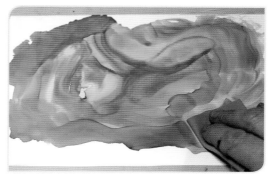

1 Create a wonderful background of colors and textures with inks on a sheet of Yupo paper.

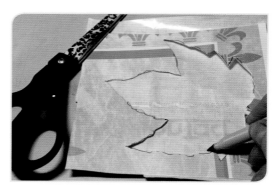

2 Draw and cut shapes from contact paper, and apply over the background colors. I am using a leaf stencil as a guide.

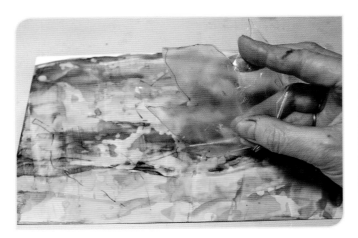

3 Stick laminate shapes onto the colored background.

4 Using a paper towel dampened with rubbing alcohol, gently blend the background colors to create a light wash.

5 Or, using craft foam, apply darker colors over the entire page.

6 When the inks are dry, remove contact paper to reveal shapes. You may continue to add and subtract ink as desired.

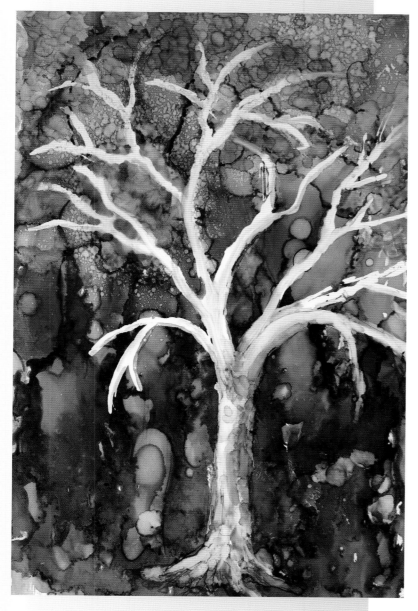

Ancient Tree | Cathy Taylor

MASKING FLUID RESIST

Masking fluid is simply a liquid plastic-type substance that may be applied to a painting to protect or reserve areas. It is particularly useful when reserving small or detailed shapes. It is easy to remove by simply rubbing it off when you are finished.

"Trust that little voice in your head that says, wouldn't it be interesting if and then do it."

Duane Michaels

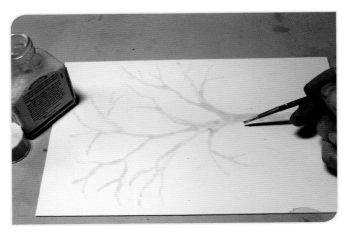

1 Apply masking fluid with an old paint brush to reserve white spaces.

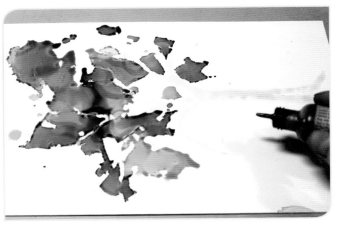

2 Drip and squirt inks onto the paper. Guide by tilting or moving with a straw or coffee stirrer.

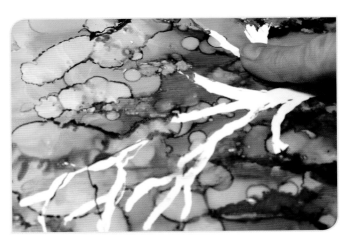

3 When ink is dry, and you have achieved the look you desire, remove the masking fluid.

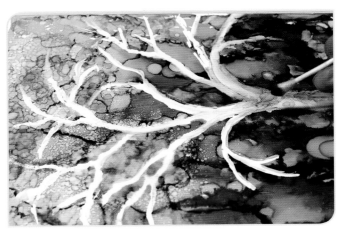

4 Add colors or details to the reserved areas with pens or ink, or spatter with rubbing alcohol to create texture.

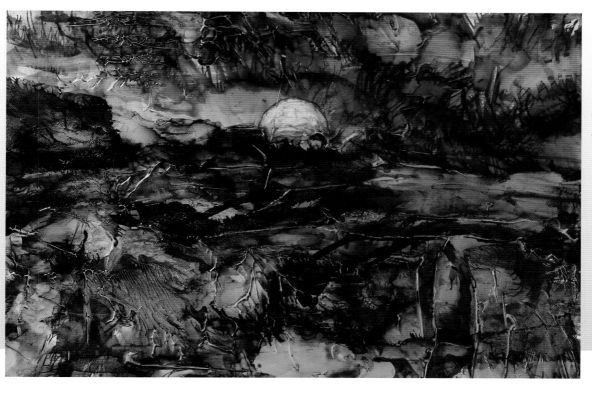

Sunset Red | Cathy Taylor

CREATING TEXTURED BACKGROUNDS WITH GEL MEDIUM

Monoprinting with gel medium is a great way to create intricate textured backgrounds. Gel medium may be used on a variety of substrates including canvas, Yupo paper, bristol paper, wood, and more. Once the substrate has been covered and printed with the gel, it becomes a beautiful nonporous, textured ground.

1 Using a palette knife, spread gel medium over the substrate. I am using Yupo paper.

2 Place another piece of Yupo (the same size) on top of the gel-coated Yupo. Press gently.

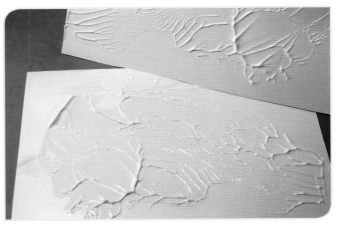

3 Remove the top sheet of Yupo. The manner in which you pull the paper off will produce different textural effects.

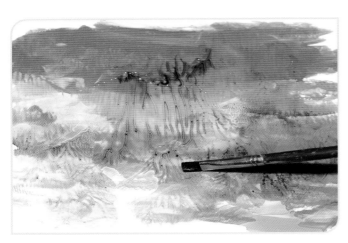

4 Allow both substrates to dry. Apply inks using a brush or cotton swab, or by dropping directly from the bottle.

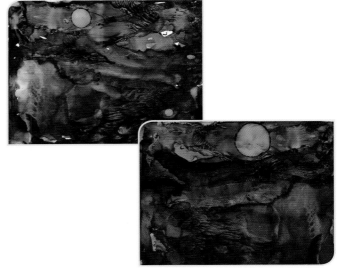

5 The textural background produces a lovely landscape or seascape effect.

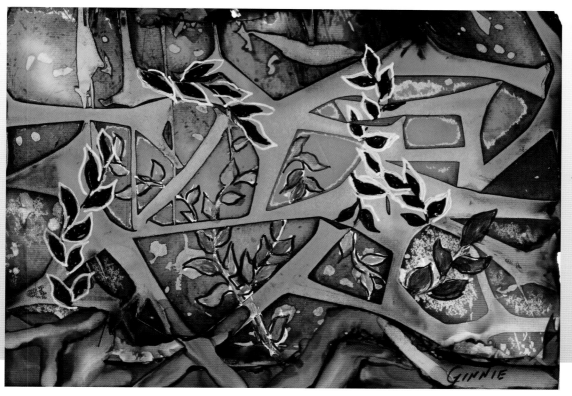

PLASTIC WRAP PAINTINGS

Watercolor and acrylic artists have used plastic wrap as a textural tool for years. When placed into wet pigment, the plastic wrap draws the pigment up into crystalline shapes. I have used plastic wrap many times to create interesting textures even in very realistic paintings. Alcohol inks and Yupo paper create a special kind of magic when plastic wrap is used. I enjoy carefully painting back into the design with inks or markers.

1 Paint, spatter, and drip alcohol inks onto a sheet of Yupo paper.

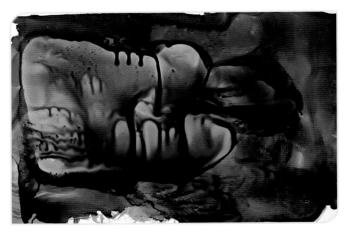

2 Use a paint brush or coffee stirrer, or tilt the paper, to move the inks quickly around the paper.

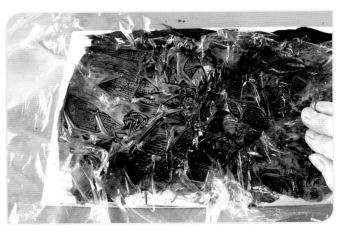

3 Crinkle a sheet of plastic wrap into the wet inks. Allow the inks to dry completely.

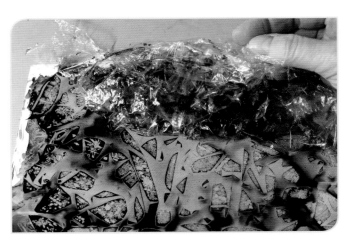

4 Remove the plastic wrap to reveal a lovely maze-like pattern.

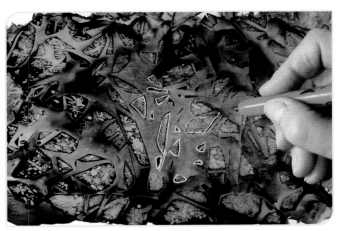

5 Using markers, work back into the design to create abstract shapes, trees, or whatever your imagination envisions.

6 You may also paint back into the design with alcohol inks.

7 Lightly mist the painting with rubbing alcohol, if desired.

3 ink-Scapes

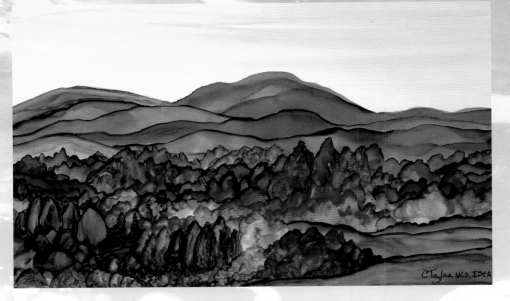

Blue Ridge Vista | Cathy Taylor

Through your glorious experimenting and controlled chaos, you have discovered a myriad of things that alcohol ink can do. So far, we have pretty much let the inks run the show, dazzling us with their tricks, daring to be controlled. In this chapter, you will learn some simple, yet effective ways to "assist" the inks as they dance on your paper. The key is to allow the inks to play as you guide them into spectacular "scapes."

— Materials for this Chapter —

- Alcohol inks

- Yupo paper

- Coffee stirrer

- Small round paint brush

- Pens and markers

- Makeup sponge

- Toothbrush

- Styrofoam produce tray

- Paper towels

- 91% rubbing alcohol

- Images (optional)

LAYING A WASH

When I worked in watercolor, I remember the painstaking lessons in laying a wash. There was the one-color wash, the graduated wash, and the variegated wash, each requiring a different application. Brush the color across the paper. Pick up the drip, and brush the color back the other way. You get the idea! Imagine my surprise when I tried this with alcohol ink. It simply wouldn't behave. After some frustrating moments and delightful experimentation, I came up with the easiest wash ever.

1 Place a sheet of Yupo paper on a covered work surface. Take a small piece of paper towel and dampen it with rubbing alcohol.

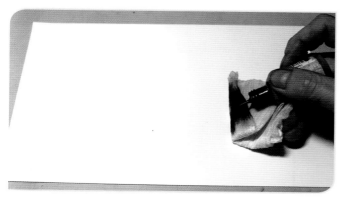

2 Squeeze a couple drops of alcohol ink onto the paper towel. You may use one or more colors to create a plain or variegated wash.

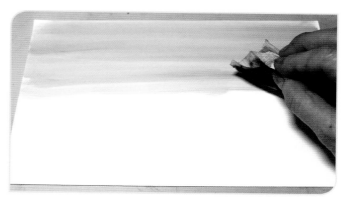

3 Gently wipe the color onto the paper starting at the top and working down to the middle of the paper in overlapping strokes. Add more drops of color to the paper towel if needed, and continue to wipe color onto the Yupo.

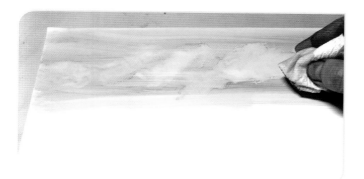

4 If desired, dab the wash with an rubbing alcohol-dampened·paper towel to create clouds.

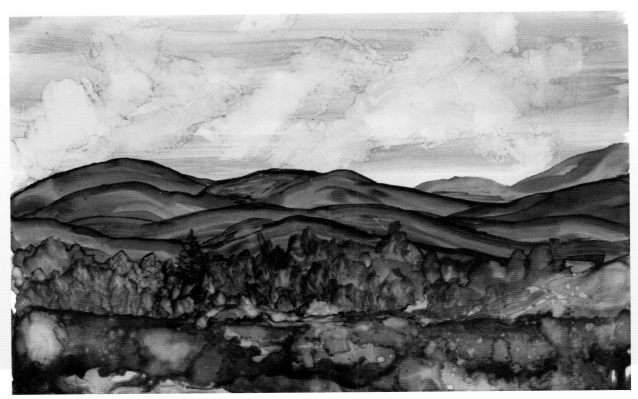

CREATING A MOUNTAIN LANDSCAPE

A wash is a basic technique used in landscapes. Now that you have mastered this "daunting" technique, let's move on to creating a landscape using a brush. Since alcohol ink evaporates quickly, I work by applying the inks directly to a small round brush. Since the inks don't leave permanent hard edges when they dry, it is easy to work back into an area to add or subtract elements.

> "A painting is never really finished; it simply stops in interesting places."
> Paul Gardner

60

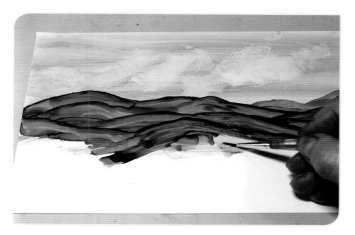

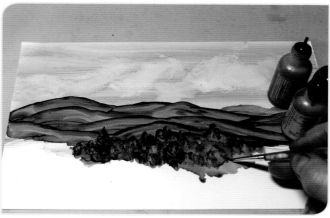

1 Squeeze a drop of ink directly onto your paint brush, and begin to paint mountain shapes. Ranger Eggplant is used here.

2 Clean the brush in rubbing alcohol. Apply ink directly to the brush, and begin to dab in the foliage and trees. Vary the colors. You will not need to clean the brush as the colors intermingle. I use a scribbling motion with the brush to create foliage. You may also use techniques already discussed, such as spattering or stamping with felt.

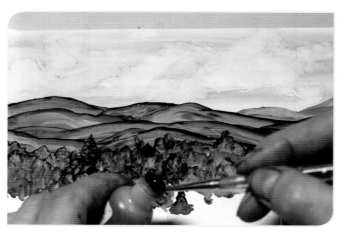

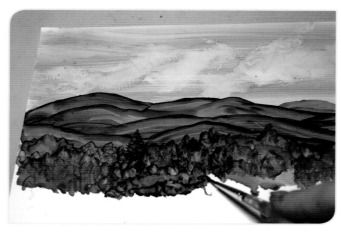

3 To achieve a dark color that will not bleed, use the ink that collects around the bottle nozzle. Some of the alcohol has evaporated, leaving the ink more stable and darker. Dab the ink from the nozzle edge and paint onto the paper.

4 Dab one color into another to create variations in colors. Alcohol ink blends without leaving lines.

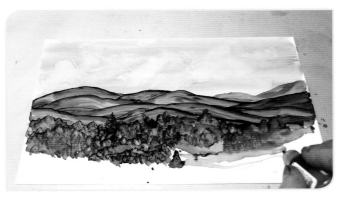

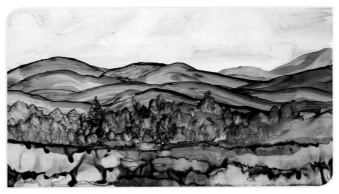

5 You may also apply the ink directly to the paper, squeezing the ink out as you draw across the paper. Guide with a brush to create rolling hills.

6 Tilt the paper at an angle and allow the inks to drip down to create a more abstract look.

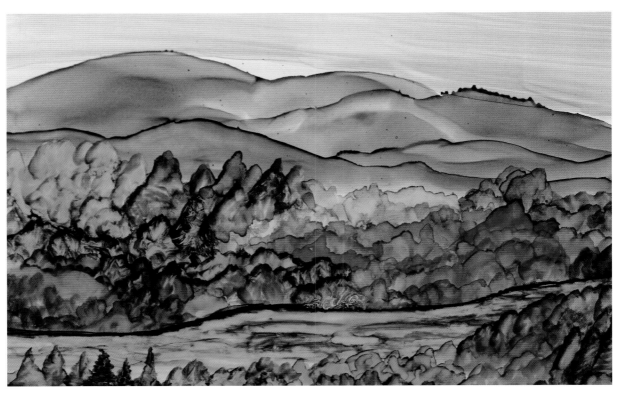

New River Sunset | Cathy Taylor

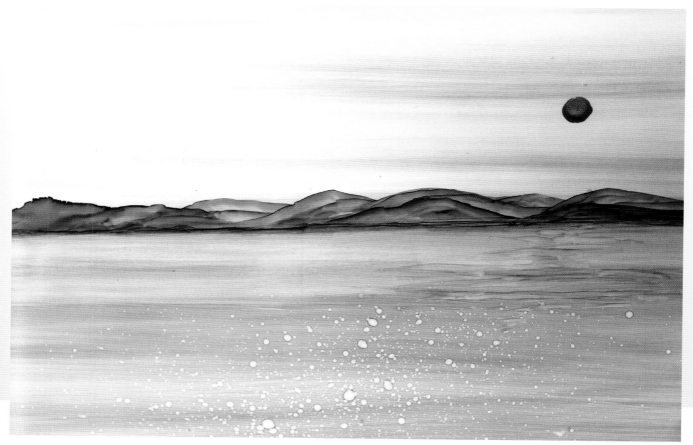

CREATING A SEASCAPE

A simple yet elegant seascape is easy to create. I create a wash over the entire surface. Remember, the water is not always blue. It will reflect the color of the sky. Also it is important to remember that the horizon line, where the sea meets the land, is always horizontal to the page. The top portion of the landmass may undulate like mountains or a tree line, but the bottom of the landmass will always run horizontal.

1 With a paper towel dampened with rubbing alcohol and inks, lay a wash on a sheet of Yupo paper. Vary the colors between sea and sky.

2 Cover the sky with a paper towel. Spatter the sea with rubbing alcohol on a toothbrush to create sparkles. With a brush dampened with alcohol, create horizontal shimmers.

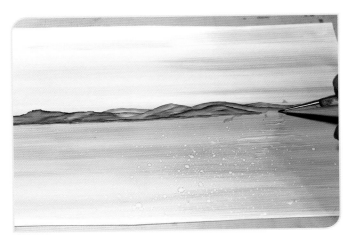

3 Paint a dark color (I like Ranger Eggplant and Denim) along the horizon line. Make sure that the bottom of the line is straight. The top of the line may be shaped like distant trees or mountains.

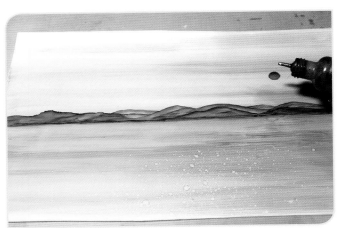

4 If desired, add a small drop of Ranger Silver or Gold for a shimmering sun or moon.

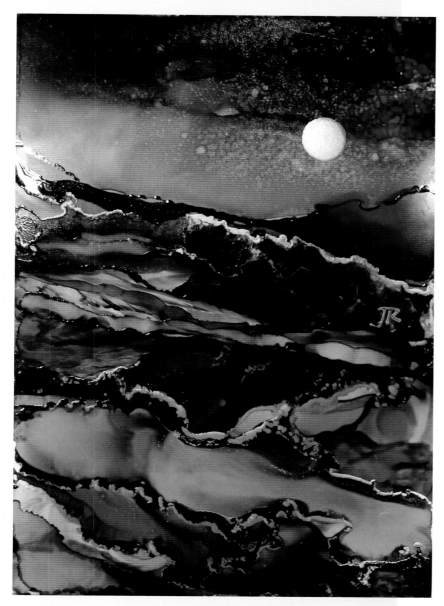

Dreamscape #424 | June Rollins

DREAMSCAPING WITH JUNE ROLLINS™

For most of her twelve-year art journey, June Rollins was a watercolor artist. In August of 2009, June took a workshop from Karen Walker on alcohol inks. She loved the unpredictable, responsive nature of the inks, and soon developed her own style of working, aptly named "Dreamscaping."

"It's a happy talent to know how to play."
Ralph Waldo Emerson

Dreamscaping with alcohol inks is intuitive, relaxing, and fun. The drop and guide process she uses, without a planned design or paint brush, creates a feeling of playful freedom. You become both the creator and the spectator as the inks perform their magic on the page.

Intuition 1) last night's dream + impulsive idea + weird uncle + too much coffee + mystical vision + unrequited desire = intuition. *(Art from Intuition* by Dean Nimmer)

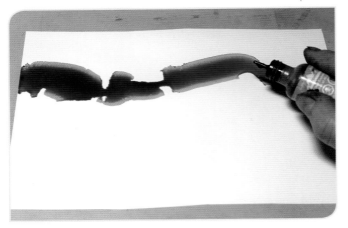

1 Gently squirt one or two colors of ink across a sheet of Yupo paper. Tilt the paper back and forth to guide the flow of ink across the paper.

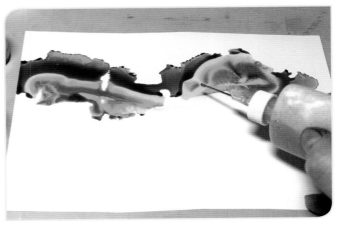

2 Add a line of rubbing alcohol using an oiler boiler.

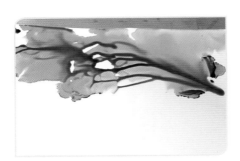

3 Apply additional ink by running the bottle's nozzle along the edge of the wet ink line and allowing to blend and flow. You may wish to wipe color from the edge with a paper towel.

4 You can use a coffee stirrer to help guide the inks into white areas.

5 Allow the ink to dry, and run additional colors into the dry inks or below the dry ink, leaving white space.

6 Continue to add colors and guide by tilting the paper.

7 Create drips by holding the paper upward.

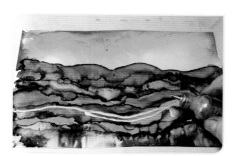

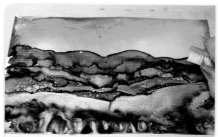

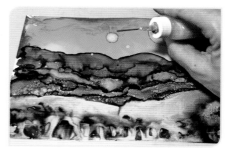

8 For a magical effect, add metallic gold or silver.

9 For a starry effect, gently mist the sky with a toothbrush dampened with rubbing alcohol.

10 Add a misty moon by placing a drop of rubbing alcohol into the sky.

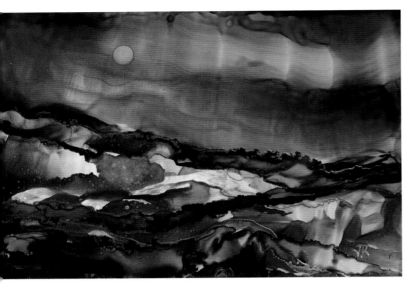

Dreamscape #425 | June Rollins

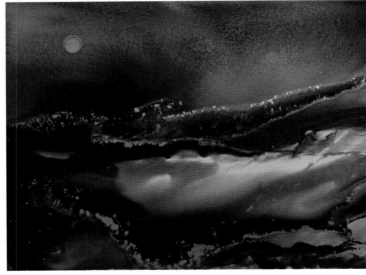

Dreamscape #42 | June Rollins

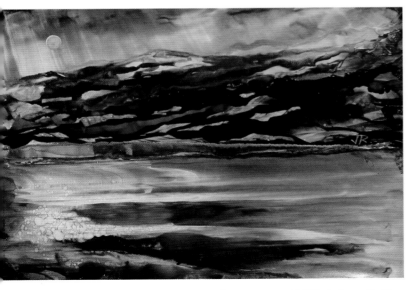

Dreamscape #426 | June Rollins

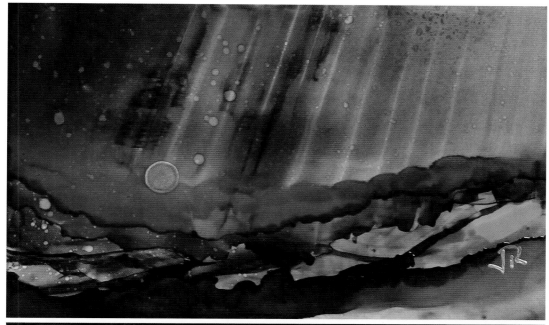

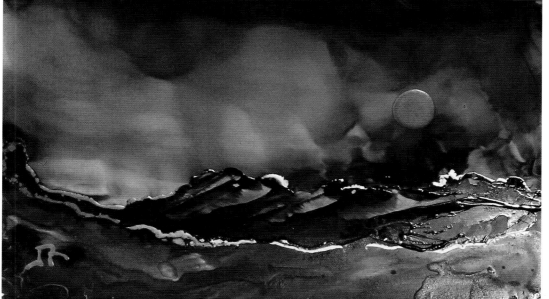

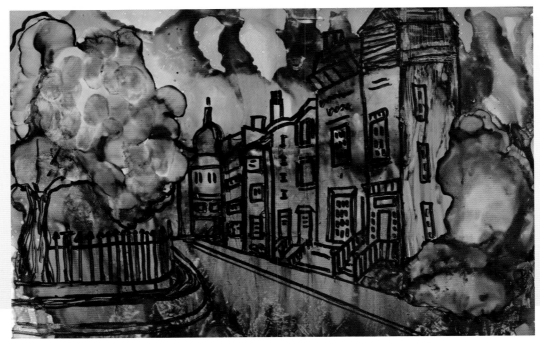

CREATING A CITYSCAPE WITH ALCOHOL INKS AND MARKERS

The swirly, drippy, flowing abstracts we created in Chapter Two can be used for fabulous backgrounds or under paintings for work done with alcohol ink pens and markers. Create your own drawing or use a traced image. This Boston street scene from a Dover Publications *Clip-Art Series®* book served as a basis for *"Street Reflections."*

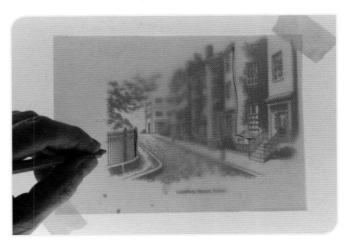

1 If you are using a traced image, place a sheet of Yupo paper over the image on a brightly lit window. The image will show through the paper. With a pencil, trace the basic outline of the design. Do not worry about the details.

2 Drop several colors of ink onto a sheet of Yupo paper. Tilt and turn the paper to move the inks.

3 Add additional colors to cover the paper. Allow the ink to dry.

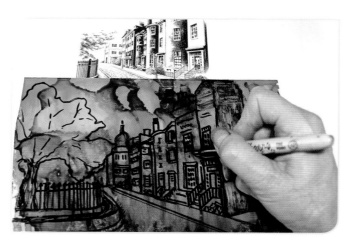

4 Using the image as a guide, draw in the details with an ink marker such as a Sharpie.

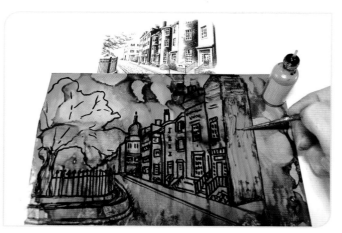

5 Add definition with a brush where desired.

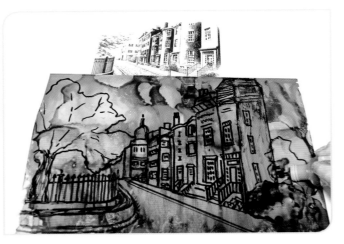

6 Use your imagination to add other elements. Drop ink into an area to create a bush.

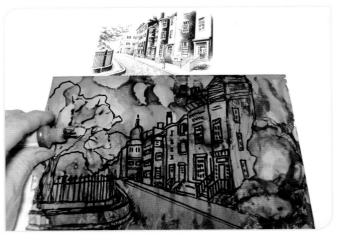

7 Add ink to areas that need additional layers, such as the tree.

Dahlia | Diane Marcotte

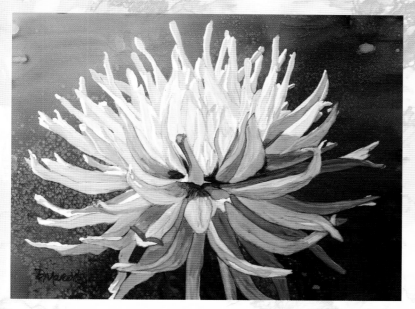

love wildflowers that grow in glorious abundance in North Carolina. Alcohol inks, with their vivid, vast assortment of colors, are perfect for creating floral artwork. The fluid nature of alcohol ink and the random interaction between colors makes creating flowers a magical experience. I also enjoy all of the forest critters that inhabit the woods around my house. It is amazing how the inks are able to mimic fur and feathers in such a textural way. Experiment using the techniques in this chapter. Combine techniques to create different effects. Create your own forest dreamland.

— Materials for this Chapter —

- Alcohol inks
- Yupo paper
- Drinking straw
- Canned air or compressor

- Hair dryer
- Small round brush
- Alcohol pens and markers
- Masking fluid

- Paper towels
- 91% rubbing alcohol
- Image to copy (optional)

CREATING BLOWN FLOWERS

"The world is mud-luscious and puddle wonderful."
e.e. cummings

In Chapter 1, we used a straw to blow flowery shapes. By combining this technique with a base wash and brush work, you can create fabulous floral "scapes."

Start with a multicolor wash. Add ink drops blown into various shapes and color combinations. Create fine details with a brush. Canned air may be used to manipulate the inks. Or, for large pieces, a table-top air compressor may be used. Alcohol ink lends itself well to the shapes and colors of flowers.

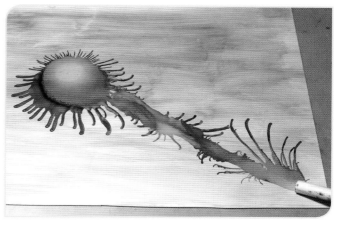

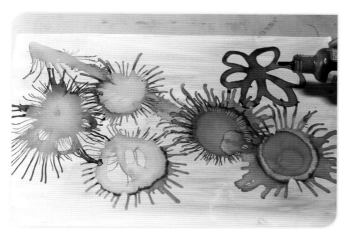

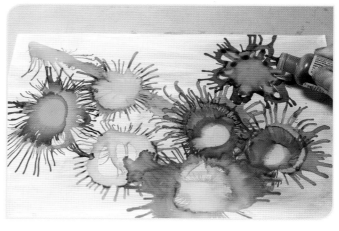

1 Lay a wash on a sheet of Yupo paper with a paper towel dampened with rubbing alcohol and ink.

2 Drop several drops of alcohol ink onto the Yupo. Quickly blow the drops with a straw. The angle at which you blow will create different shapes.

3 Draw different shapes with the ink bottle and blow with the straw.

4 You can also vary the effect by the distance the straw is from the paper. Continue to place drops of ink into the floral shapes and blow layers of color.

5 For a different effect, blow quickly into a drop of ink and allow the ink to run back into itself. Canned air may be used to manipulate the inks. Or, for large pieces, a table-top air compressor may be used.

6 Apply other colors and shapes to the paper with a small brush. Alcohol ink colors will blend with each other to create wonderful back-runs, textures, and new colors.

7 I keep paper towels handy to blot excess or dirty ink from my brush.

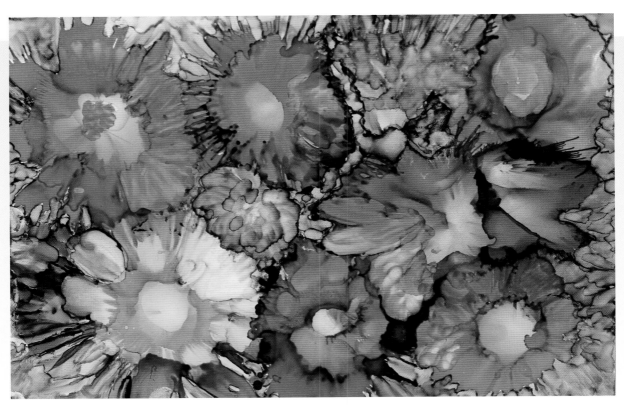

Floral Fiesta | Cathy Taylor

ENHANCING AND BLENDING FLOWERS

Using alcohol to soften and blend the inks creates lovely watercolor effects. The lighter areas provide a contrast to the vivid color of the inks. Softening some areas also creates a feeling of depth in the painting.

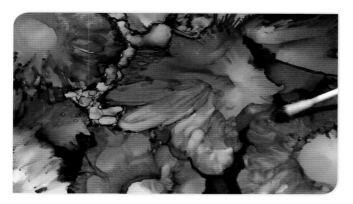

1 Flower shapes may be enhanced by working back into the painting with rubbing alcohol. Using a cotton swab dampened with rubbing alcohol, gently wipe into the flower shapes to create softer petals and lighter passages.

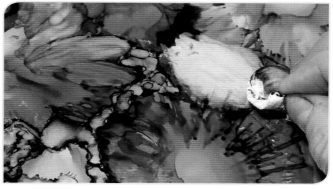

2 Change the cotton swab often to avoid muddy colors. Muddy areas may be wiped off entirely using rubbing alcohol or blending solution.

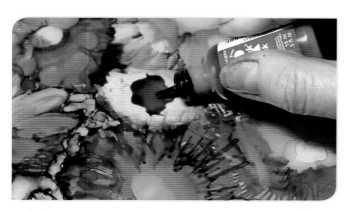

3 Add inks back into these areas with a brush or by dropping inks back onto the Yupo.

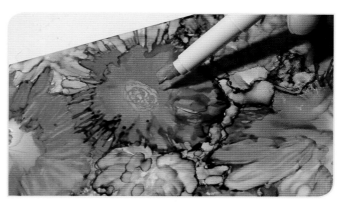

4 Add details with alcohol ink pens and markers.

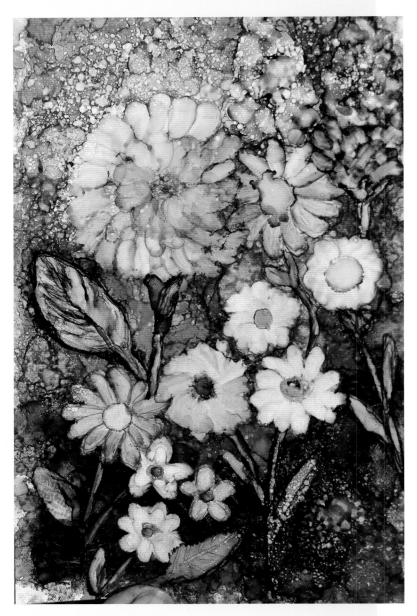

Spring Fling | Cathy Taylor

FELT STAMPED FLOWERS

We created a beautiful marbled effect in Chapter 1 by stamping inks onto the surface with felt. By working back into the marbled background with rubbing alcohol, removing ink or softening edges, you can create lovely soft flower and leaf shapes. Use other techniques, such as spattering rubbing alcohol with a toothbrush, to add additional texture.

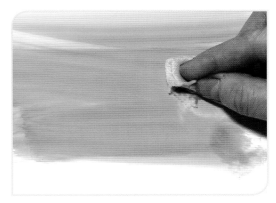

1 Lay a multicolored wash on a sheet of Yupo paper with a paper towel dampened with rubbing alcohol and ink.

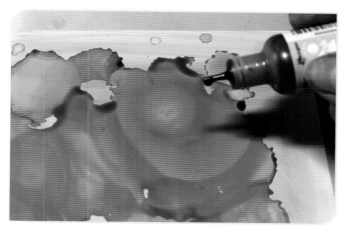
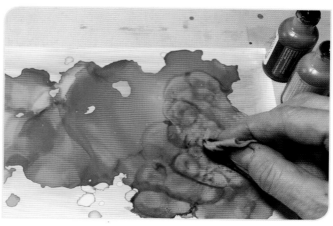

2 Drop several colors of ink into the wash. Allow the ink to dry.

3 Drop one or two colors of ink onto a clean piece of felt. Randomly stamp the Yupo with the felt. Add other colors and repeat the process. Change the felt square as needed. Continue to stamp additional colors until you have achieved an interesting and varied background.

4 Using a small brush or cotton swab dipped in rubbing alcohol or blending solution, work back into the background pulling out floral shapes. Clean the brush often on a paper towel.

5 Continue to paint with rubbing alcohol, lightening areas of color. If desired, add color back into the painting using a small brush.

6 Lightly spatter rubbing alcohol with a toothbrush for added texture.

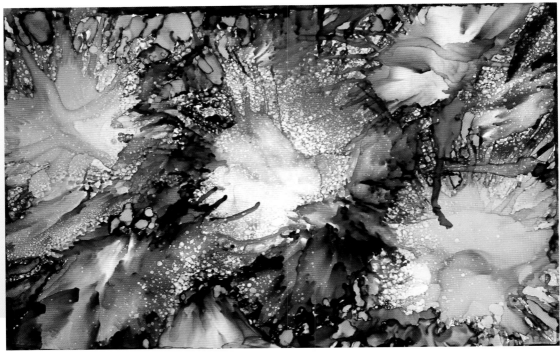

USING A HAIR DRYER TO CREATE FLORAL SHAPES

I like using a hair dryer on the cool setting to manipulate the inks. Sometimes I will brush rubbing alcohol onto the surface, drop the inks into the alcohol, and blow them with the blow dryer. At other times, when I want to create soft passages or lighten colors, I will spritz the dry ink with alcohol and then quickly blow the area with the hairdryer. A hair dryer will create different effects than blowing with a straw.

1 Drop inks onto a sheet of Yupo paper and allow the colors to mix and mingle. Tilt the paper and use a straw to assist the ink in moving around the paper. Allow ink to dry.

2 Gently spritz rubbing alcohol onto the paper. Spritz from an arm's length distance to achieve a fine texture.

3 With a hair dryer on low setting, gently dry the misted area.

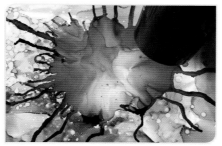

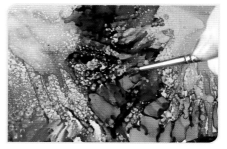

4 Choose an area to create a large bloom. Draw a flower shape onto the background using the tip of the ink bottle.

5 Spray the area liberally with rubbing alcohol and immediately blow with the hair dryer on high setting, straight down onto the ink. This will produce a lovely blossom.

6 Continue the process, adding colors as desired. Use a brush or marker for details.

"The earth laughs in flowers,"
e.e. cummings

I am fascinated by the amazing versatility of alcohol inks. They can be used on virtually anything with a nonporous surface. In addition, I have found that you can coat a porous surface such as stretched canvas with acrylic medium to allow the inks to work their magic. The more I work with the inks, the more familiar I become with their qualities and characteristics. This allows me to create with more control even in paintings that seem arbitrary or highly abstracted.

Of course I still love the unexpected surprises that occur when working with alcohol inks. That is part of their charm. Gaining a certain understanding of the way the inks interact and the methods of manipulating them has allowed me to take the leap and work BIG. Alcohol inks make a visual impact even on a small scale, but they are spectacular as a twenty- by thirty-inch painting. I have invited artists Diane Marcotte, Wendy Wilkins, and Karen Walker to share their secrets in creating gorgeous, more intricate paintings.

USING RESIST TO CREATE FLORALS WITH DIANE MARCOTTE

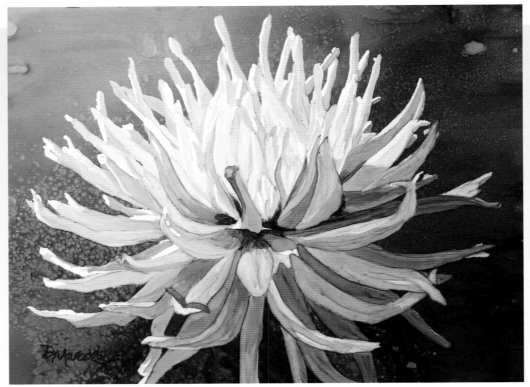

Dahlia | Diane Marcotte

Be sure to apply a heavy layer of masking fluid. This will prevent ink from bleeding through. It also leaves a crisper edge and makes removal easier. Let the masking fluid dry completely, at least two hours. Use your time to start another painting or sketch out and mask several paintings at one time.

1 To transfer a drawing to the Yupo paper, tape the drawing to the Yupo.

2 Hold the Yupo and the drawing on a window and trace the design.

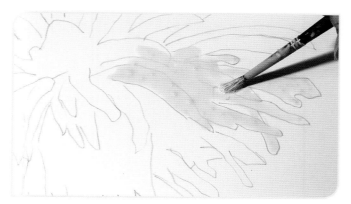

3 Using masking fluid, mask the entire flower, staying just within the pencil lines of the petals that protrude into the background. (The pencil lines will disappear beneath the background ink.)

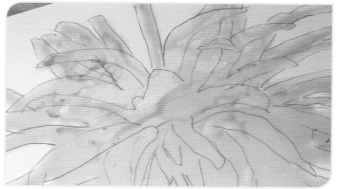

4 Once masking is dry, apply rubbing alcohol over the entire painting. Make sure the background is completely covered by tilting the painting from side to side. (This helps the ink to flow smoothly.)

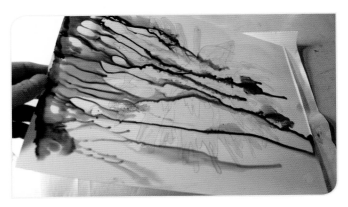

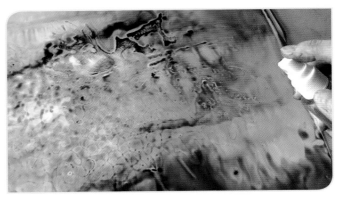

5 Turn the painting on its side with the left side uppermost. Liberally apply a light shade of green ink starting at the top edge. Add a darker shade of green ink about two-thirds of the way down the painting. Tilt the painting back and forth to ensure the ink covers all of the background. The two shades of green should mix slightly but the darkest shade should be at the bottom (the right side of the painting).

6 It is fine for some hard edges to form, but the overall background should be fairly smooth. Just before the ink is dry, lightly mist rubbing alcohol in a couple of areas. This creates texture and smoothes out some areas that may have too many hard lines. Let the painting dry for at least an hour.

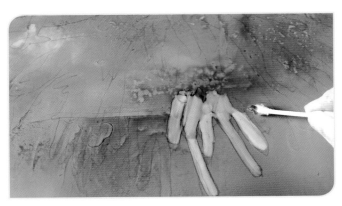

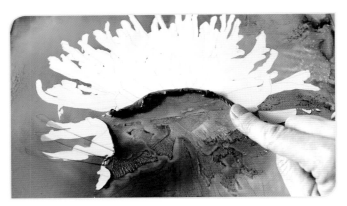

7 Using cotton swabs dipped in rubbing alcohol and blotted to remove excess, gently lift away any thick areas of ink that have settled on the masking. Take care on the petals that protrude into the background so that the alcohol won't run into the background. This will prevent ink from staining the paper as the masking is removed.

8 Allow the painting to dry for at least an hour. Gently remove the masking using your fingers.

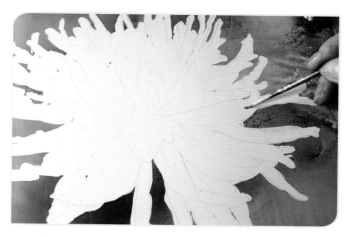

9 Re-mask the highlight areas of the flower.

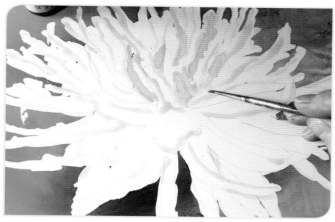

10 With a small brush and pale yellow ink, paint the yellow parts of the flower. With pale pink ink, paint the individual petals that are to be the lightest shade.

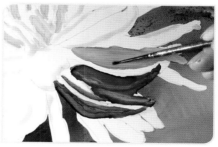

11 With a deeper pink, to which a drop or two of a pure blue ink has been added, paint the petals that are on the right side, which are away from the light. Vary the color slightly from petal to petal, by increasing or decreasing the amount of blue added so that there is some variety. Colors may be mixed on a piece of waxed paper.

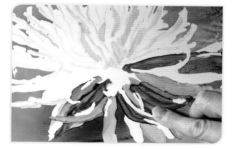

12 Remove the masking on the petals. Paint the white areas a pale shade of pink on the petals that are in shadow. Mix a shade of deep purplish red for the darkest shadows. Apply with a light touch in order not to disturb the color beneath.

13 Dip a cotton swab in rubbing alcohol. Dab on a paper towel to remove excess rubbing alcohol. Draw a stem by dragging the cotton swab through the background ink. Redo with another swab if necessary. Once dry, add some dark green ink to the right side and blend to create some roundness to the stem.

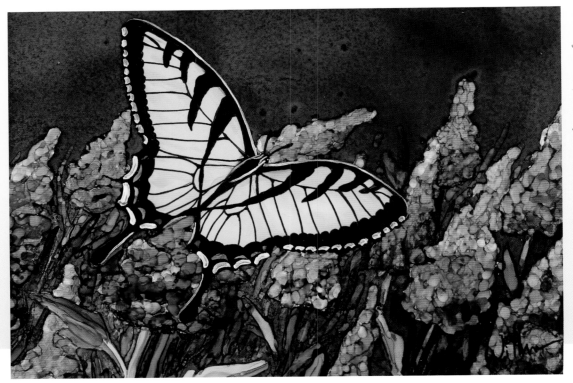

FLORAL-SCAPE USING RESIST AND MARKERS
WITH WENDY WILKINS

When creating a detailed painting, planning is just as important as the process of painting. Taking your time with the following steps will lead to a better finished piece. You will want to visualize your finished piece. Find a picture or photo of what you want to create and spend some time inspecting the detail. You will want to refer back to your inspiration pictures often, so get to know them before you begin.

Decide which colors you want to use. With ink, less is often more, so limit yourself to three to five colors. Repeating colors gives your painting unity.

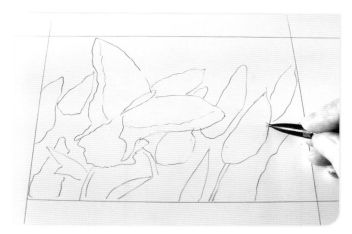

1 Draw your image on a sheet of Yupo paper. Make your marks light and avoid unnecessary detail.

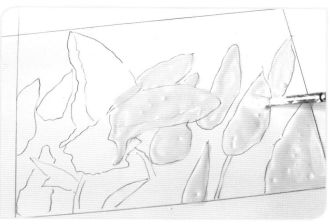

2 Using a disposable brush and masking fluid, fill in the foreground areas of the butterfly and flower. Mask everything that needs a sharp edge and is a different color than the background. The leaves and stems are not masked as they blend with the background color. Allow masking to dry.

3 Select two or three analogous colors. Working from the background forward, apply colors in an abstract manner. Drip the inks directly onto the paper.

4 Use a brush or tilt the paper, and allow colors to blend and mix.

5 After the inks are dry, rub off the masking fluid. Gently use your fingertip to rub the outside edge to the middle.

6 In the painted background, use a brush or cotton swab dipped in rubbing alcohol to lighten areas. Paint with inks to darken an area or create detail.

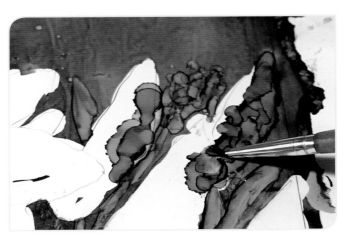

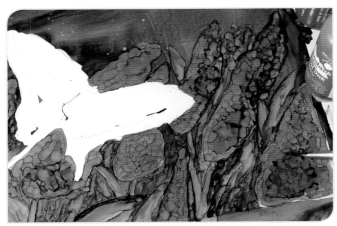

7 For the flowers, use a dark color to paint the shadows. Then apply lighter colors over and around the shadows.

8 Continue to add dots of color with a brush. Use rubbing alcohol to lighten areas. Gently dab into areas to give the feeling of petals rather than individually painting each one.

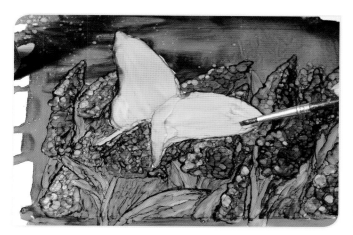

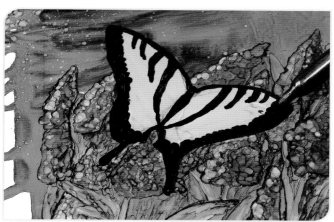

9 For the butterfly, paint the dominate color first. Ignore details and just fill in the wings with the main color. Details will be added over the main color.

10 Use an alcohol ink pen to add dark details such as veins in the wings.

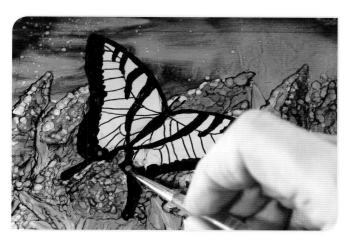

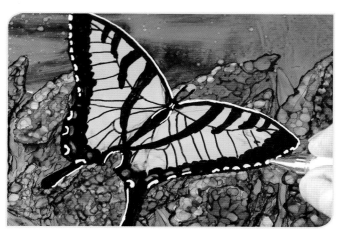

11 With a small brush, add color details of blue and red.

12 Using opaque white ink, paint white areas of the wings over the black ink. (Make sure that the black ink is totally dry before you do this.) You may also use a white marker to add detail. (I like the Signo pen by Uni-ball.)

SPLASH, SPATTER, AND PAINT A DUCK!
WITH KAREN WALKER

One of the wonderful things about working with alcohol inks is that the artist has the ability to work in a very spontaneous way that allows the inks to work in their mercurial way. Then the inks may be controlled using a small brush and very exact application to create tiny details and delicate nuances.

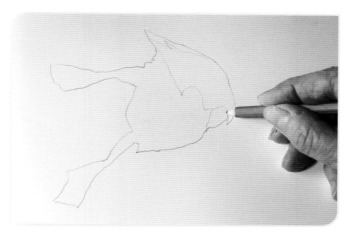

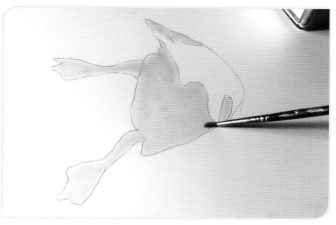

1 With a pencil, lightly create a drawing on a sheet of Yupo paper.

2 Using a small brush, paint the white areas and detailed areas of the duck with masking fluid. Allow the masking fluid to dry completely.

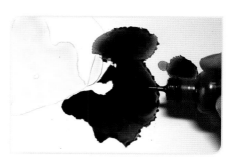

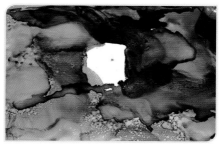

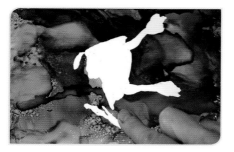

3 Apply a variety of inks to create a watery background. In this example, Ranger's Bottle, Eggplant, Stream, and Lettuce were used.

4 Tilt the paper to blend the inks and allow the painting to dry.

5 With your fingers, gently remove the masking.

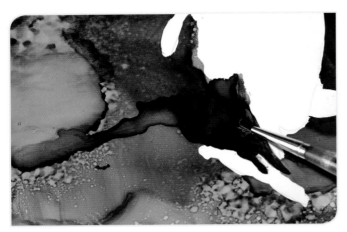

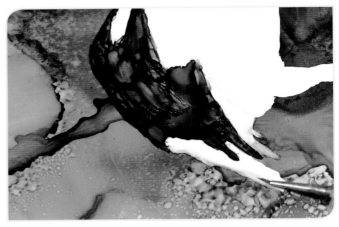

6 Begin by painting the dark area of the duck. Make sure not to load the brush with too much ink in order to maintain control. If there is too much ink on the brush, it will cause the ink to run into the background.

7 Using a clean brush dampened with rubbing alcohol, touch the edges around the white areas to soften and create very light shadows.

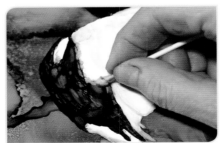

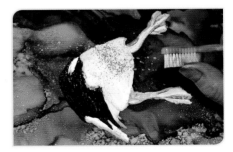

8 Carefully add in shadows and highlights. I am using Pool for shadows and Lemonade for highlights.

9 Using a cotton swab dampened with rubbing alcohol, gently soften the area between the dark and light shapes.

10 With an old toothbrush, spatter gold ink gently over the painting. You may also wish to spatter a touch of rubbing alcohol.

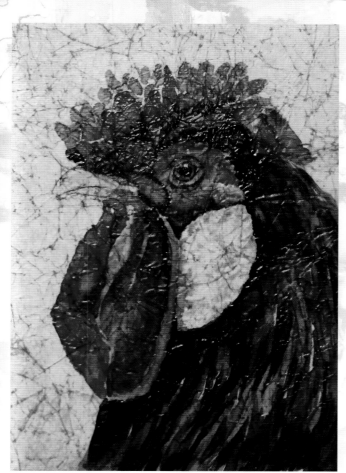

Red Rooster | Billie Crain

grew up in the sixties; thus, I am a big fan of tie dye. In my teens, I learned to sew in my 4H club and fell in love with interesting and exotic fabrics. I traveled to Thailand, India, and Nepal and came home with beautiful batiks, sensuous silks, and colorful Madras fabrics. Even though alcohol inks are formulated for use on nonporous surfaces, you can achieve some incredible effects on fabric using the following techniques. So get out some waxed paper and some shaving cream and have some fun!

"Think left and think right, and think low, and think high. Oh the things you can think up if only you try."
Dr. Seuss

- Alcohol inks
- Yupo paper
- Waxed paper
- Freezer paper
- Bristol paper or claybord
- Black India ink
- Small round paint brush
- Clear or white acrylic gesso

- Alcohol ink pens and markers
- Acrylic gel medium
- Hake brush
- Soft brayer
- Paper towels
- 91% rubbing alcohol
- Krylon spray varnish

- Old credit card
- Styrofoam tray
- Cookie sheet
- Shaving cream
- Coffee stirrer
- Fabric

BATIK WITH BILLIE CRAIN

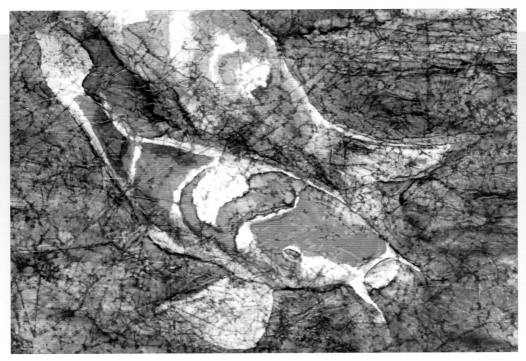

Koi | Billie Crain

Waxed paper is a great tool for creating textures with watercolors, acrylics, and inks. Surprisingly, it is also a super surface for creating a painting, specifically a beautiful batik-style painting. Artist Billie Crain developed a wonderful, creative technique for a batik-style of painting with alcohol ink.

1 Cut a piece of waxed paper about an inch larger than your backing paper. Crumple the waxed paper into a ball, then smooth it out, then re-crumple until little creases are evenly distributed across the paper. Avoid long, straight lines.

2 Using full-strength black India ink and an old, stiff bristle brush, paint the surface of the waxed paper. Allow the ink to settle into the creases.

3 Wipe away the excess with a damp paper towel.

4 Place the waxed paper on a clean white surface to see the batik effect. If you wish to use a drawing as a guide for your painting, place the template underneath the waxed paper. Make sure the drawing is dark enough to see.

5 Squeeze a small amount of ink onto a small round paint brush and paint onto the waxed paper. Rinse the brush in rubbing alcohol and continue to add additional colors.

6 Markers may be used to add fine details.

7 When the painting is complete, adhere the waxed paper to the substrate. Apply a thin, even coat of acrylic gel medium to a smooth surface such as bristol paper, Yupo, or Claybord.

8 Place the waxed paper painting onto the surface and gently smooth into place. Use a soft brayer to smooth out any air bubbles or lumps of gel.

9 Trim the excess waxed paper and allow the painting to dry. You may seal the painting with Krylon spray varnish, if desired.

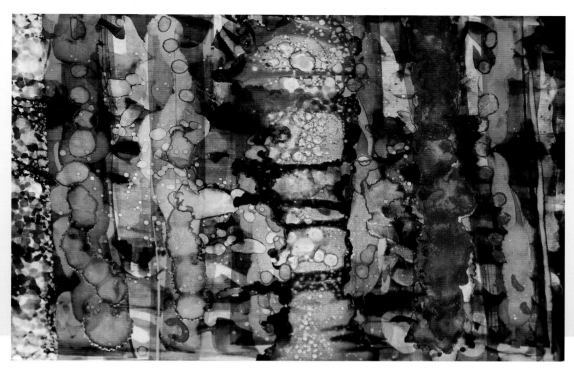

Blue | Cathy Taylor

MADRAS EFFECTS

I love the look of madras; the muted, layered colors are gorgeous. You can create a madras effect by layering and scraping the inks. Amazing shapes and patterns emerge as you apply and remove inks. You can use the finished product as a magical background or simply enjoy the painting as an interesting abstract.

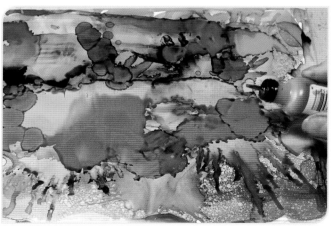

1 Brush, drip, and blend assorted colors onto a sheet of Yupo paper. Allow them to dry.

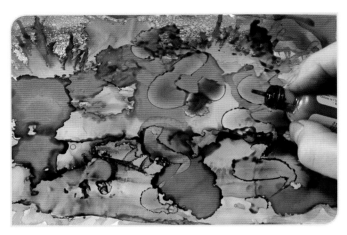

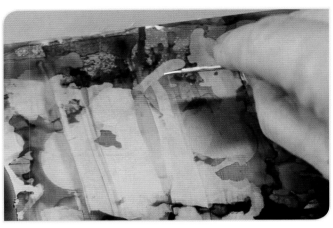

2 Squirt lines of contrasting colors in one direction across the paper. Allow the colors to spread a little.

3 Using a credit card or palette knife, scrape colors away. Clean the scraper with paper towels. I scrape the excess ink onto another sheet of Yupo for use later.

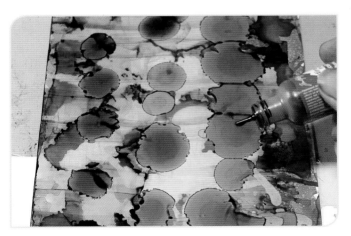

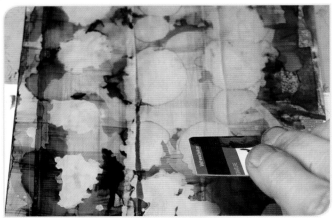

4 Turn the paper and squirt lines in the opposite direction. Scrape through the colors to remove the inks.

5 Spatter, drip, or drop additional ink colors onto the paper, and repeat the process.

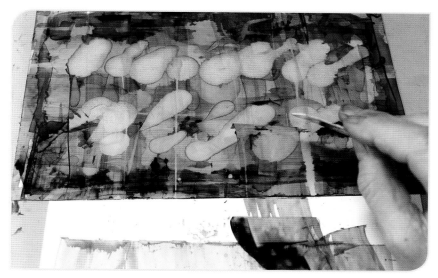

6 Paint into the design, use alcohol ink pens to add detail, or spatter with alcohol on a toothbrush. A little Piñata Gold adds sparkle.

When scraping off excess ink, scrape it onto another piece of Yupo to use as a start for another creation.

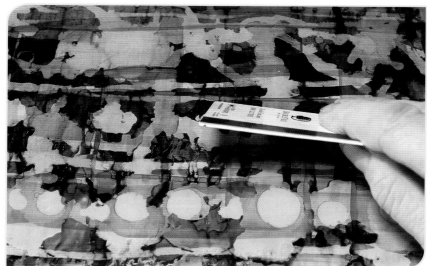

7 Continue to layer and scrape until you are happy with the design.

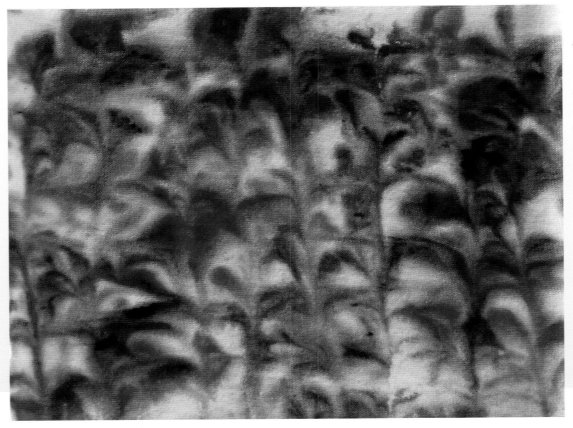

MARBLING FABRIC

I borrowed this idea from the grade-school playbook. I was trying to figure out how to get the alcohol ink to create a marblized effect on fabric without turning the fabric into plastic. I tried coating the fabric with gel medium or varnish, but the fabric was then essentially plastic. I recalled a technique from my grade-school days using shaving cream to create marbling. "What if" I applied alcohol ink to shaving cream and pressed fabric into the mess? It actually looked like a mess when I pulled the fabric up, until I scraped off the shaving cream. Voilà, marbled fabric.

1 Squirt shaving cream into an old foam produce tray or old cookie sheet. Smooth the surface flat with a large scraper or credit card.

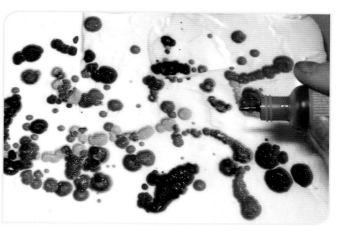

2 Drop various colors of alcohol inks into the shaving cream.

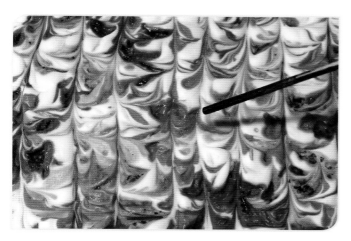

3 Using a coffee stirrer or skewer, draw through the shaving cream to create vertical lines. Clean the skewer often with a paper towel. Repeat the process horizontally, or create swirls.

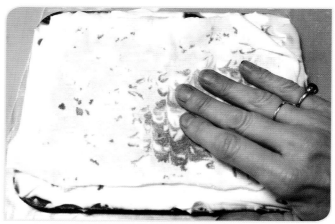

4 Carefully lay a neutral-colored fabric on top of the shaving cream, and smooth gently.

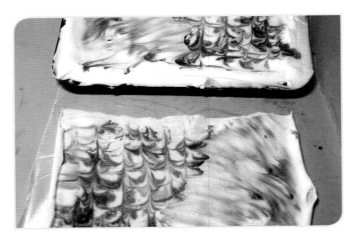

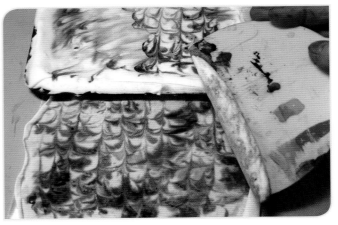

5 Remove the fabric, and lay it flat.

6 With a large scraper, remove the shaving cream. A beautiful marbled effect will remain on the fabric. Heat-set with an iron, or use a clothes dryer.

SWIRLING SILKS

Thin, soft, smooth fabrics such as silk lend themselves to alcohol ink-dyeing. You can achieve gorgeous color washes and blends.

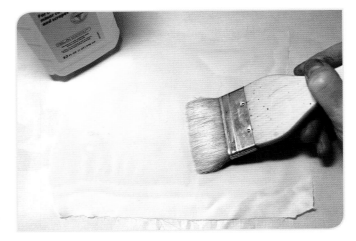

1 Place silk fabric on freezer paper. Using a hake brush, coat the fabric with alcohol.

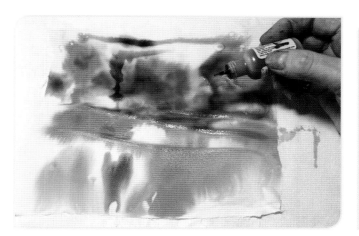

2 Drop inks onto the fabric.

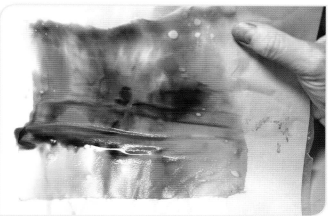

3 Lift the freezer paper, and allow the inks to intermingle.

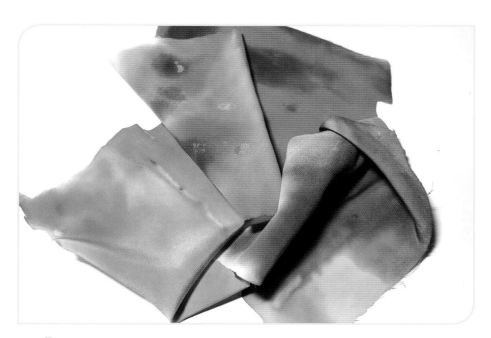

4 Allow the fabric to dry. Heat-set.

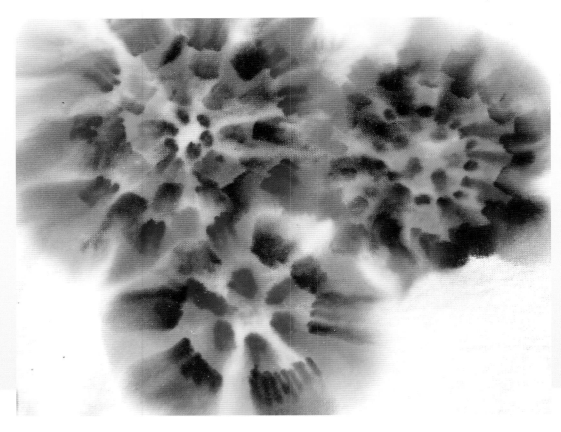

THE TIE-DYE EFFECT

Inspiration for this technique comes from my teen years. I grew up in Boulder, Colorado, in the sixties (my husband says that explains a lot!). Couture de rigueur at the time was a torn pair of bell bottom jeans, a bandana, and a groovy tie-dye shirt. It is easy to create a tie-dye effect using alcohol markers and a little rubbing alcohol.

When working with rubbing alcohol, work in a well ventilated area. When heat-setting fabrics, use a protective sheet under and on top of the fabric in case it bleeds.

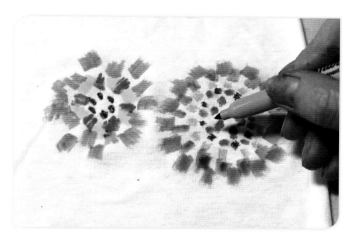

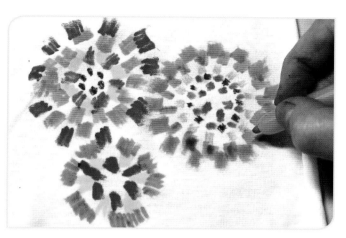

1 Place soft cotton fabric on freezer paper. Using alcohol markers, draw a series of dots in a circular pattern.

2 Continue to create designs with different colors until the fabric is covered.

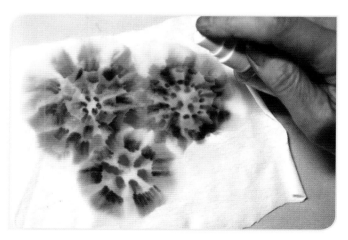

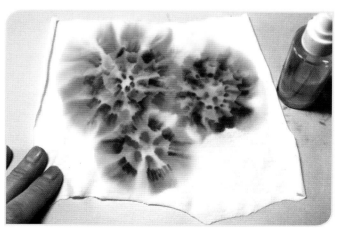

3 Gently mist the swirls of color with rubbing alcohol. Colors will blend and mix. Heat-set.

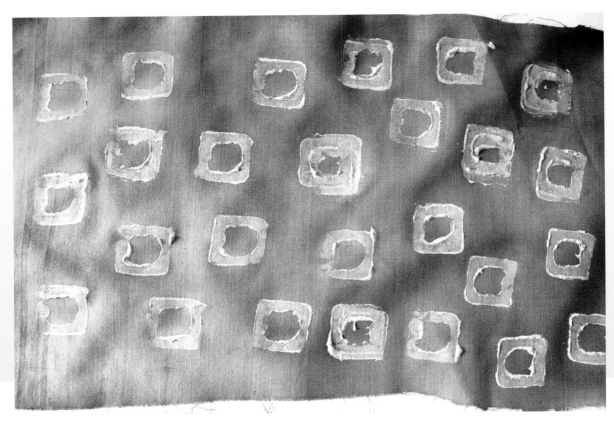

ADDING PATTERNS AND TEXTURES TO FABRICS

I have a major collection of stamps. Some I have purchased from arts and crafts stores, but most of my stamps are handmade. I carve into erasers, emboss foam produce trays, and use found objects as stamps. Use plain white gesso and your favorite stamps to create interesting patterns on fabric. When you apply alcohol inks, the gesso will act as a resist, leaving subtle patterns and textures. Gesso is acrylic based and is flexible when dry, so the fabric will remain pliable.

1 Place a smooth, tightly woven fabric on freezer paper. Pour a small amount of gesso into an old Styrofoam produce tray.

2 Tap your stamp into the gesso, picking up a uniform layer on the stamp.

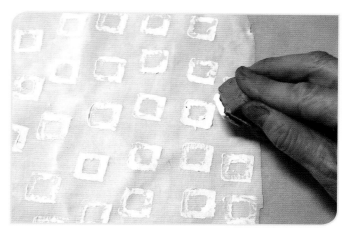

3 Stamp the gesso onto the fabric. Repeat until the fabric is covered. Allow the gesso to dry.

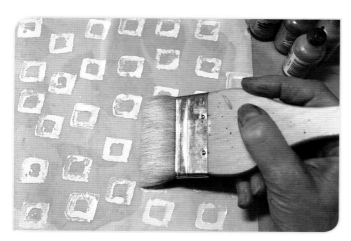

4 With a hake brush, coat the fabric with rubbing alcohol. Remember to work in a well-ventilated area.

I found a cool website that allows you to upload your own artwork and design a garment. The garment is custom-made to order just for you! www.constrvct.com.

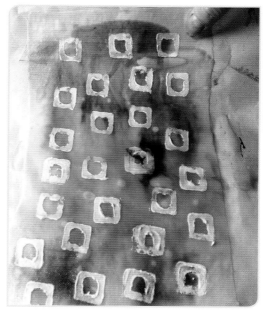

5 Drip, drop, and brush inks onto the fabric. Allow the fabric to dry. Heat-set with an iron or clothes dryer.

6 Everything Else

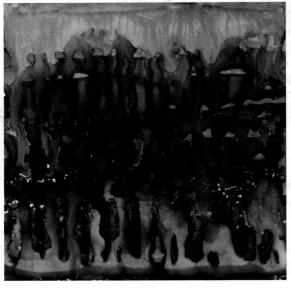

You can create amazing paintings using alcohol ink, but the fun doesn't stop there. Alcohol ink works on metal, ceramic tile, plastic, glass—anything nonporous.

— Materials for this Chapter —

- Alcohol inks
- Yupo paper
- Bristol paper
- Terraskin paper
- Cookie tray with sides
- Acrylic gloss medium and varnish
- Coffee stirrer or palette knife

- Sheet of glass or plexiglas
- Ceramic tiles
- Small paint brush
- Faux stained-glass leading
- Design to copy (optional)
- 91% rubbing alcohol
- Tar/string gel
- Aluminum beverage cans

- Disposable syringe
- Odds and ends of papers and plastic
- White tape
- Pencil
- Toothbrush
- Markers
- Scissors
- Paper towels

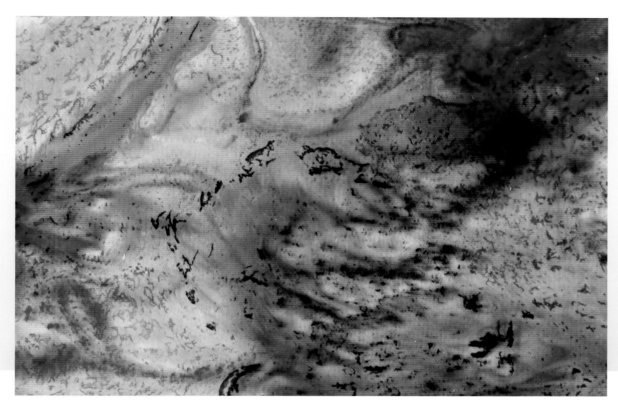

CREATING ACRYLIC SKINS

I have seen acrylic skins created by using acrylic medium or tar gel with acrylic paints. The skins are interesting and colorful and may be used in collage, cut up for mosaics, or combined to create a dimensional painting. When using alcohol inks to create acrylic skins, the effect is far more spectacular. The vivid, glowing colors create the look of stained glass. I have actually taken some of my creations and stuck them to my studio windows where they adhere by themselves!

1 Squirt gloss medium into a cookie tray to create a one-quarter-inch layer.

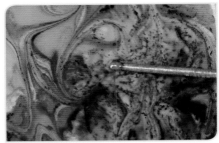

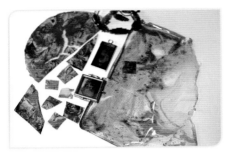

2 Drop inks into the medium.

3 Swirl the inks with a coffee stirrer. Allow the medium to dry thoroughly. Carefully peel the skin from the tray.

4 Skins are wonderful for use in collages, cut into small shapes for mosaics, or cut into long triangles and roll to make gorgeous beads.

METAL MAGIC

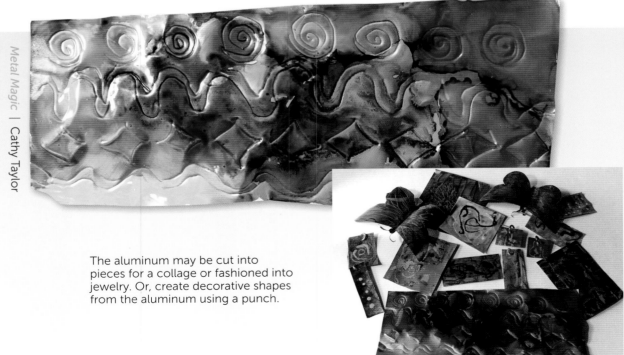

Metal Magic | Cathy Taylor

The aluminum may be cut into pieces for a collage or fashioned into jewelry. Or, create decorative shapes from the aluminum using a punch.

Alcohol inks work on nonporous surfaces. You can paint on light switch plates, jewelry findings, aluminum foil, and more. I love finding ways to recycle or upcycle materials for my artistic endeavors. I am fascinated with mixed media and found-object collage. Always on the lookout for fun, new materials, I was thrilled to discover that alcohol inks transformed deconstructed beverage cans into precious, colorful aluminum collage material.

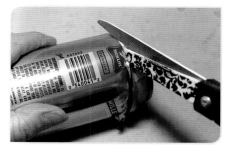

1 To deconstruct an aluminum can, carefully punch one blade of your scissors into the side of the can below the top. Cut around the edge to remove the top.

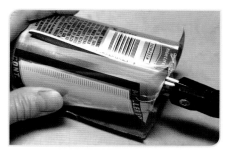

2 Cut down the side of the can to the bottom.

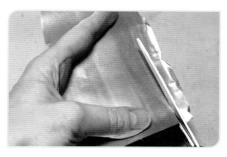

3 Cut around the can to remove the bottom.

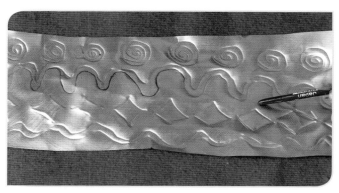

4 Lay aluminum on a felt square, and using the handle end of a small brush or a blunt pencil, emboss designs onto the metal.

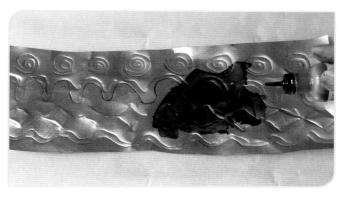

5 Apply inks by dripping or brushing, and allow them to blend and dry.

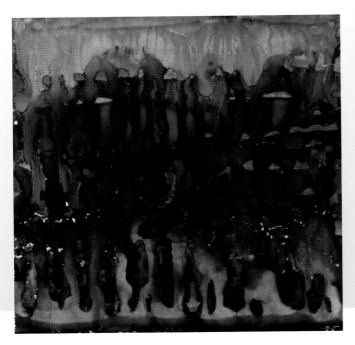

Blue Veil | Cathy Taylor

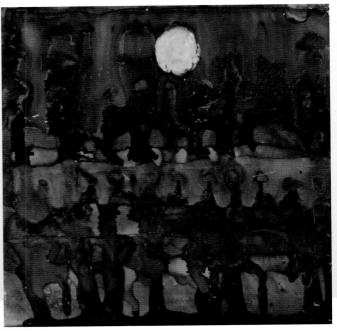

Blue Moon | Cathy Taylor

CREATING COLORFUL CERAMIC TILES

Glazed ceramic tiles come in all shapes and sizes and are nonporous. This makes them a perfect vehicle for alcohol ink exploration. You can find ceramic tiles in the open stock section of a home improvement store, and they are very inexpensive. Any of the ink techniques in this book may be used on tiles. When sealed with varnish, they make great coasters or trivets. For a fantastic artful gift, purchase a precut box, lamp base, bird house, or other wood structure, mount your tile, and admire your masterpiece.

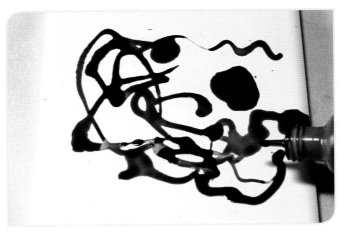

1 Randomly squirt several colors of ink onto the tile.

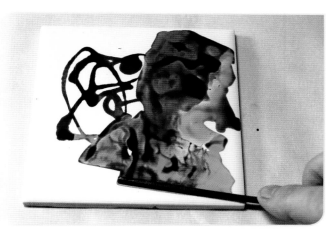

2 Manipulate the inks by tilting the tile and guiding the inks with a coffee stirrer.

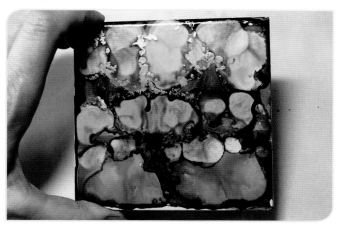

3 Add a line of Piñata Gold to the top of the tile, followed by a line of alcohol. The alcohol will push the gold into the other inks.

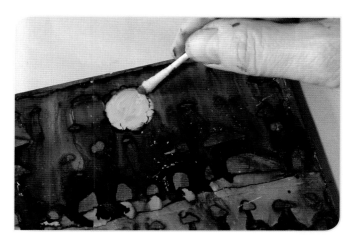

4 If desired, use markers or a fine brush to add details. Or use a brush or cotton swab dipped in rubbing alcohol to create lighter areas.

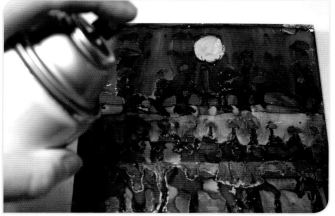

5 Seal the finished tile with spray varnish. Quickly spray a light coat across the tile to avoid moving the inks. When the varnish is dry, apply another coat.

A company called Aftosa creates many precut substrates for tiles. Also, visit your local arts and crafts stores for wonderful wood products such as trays and plaques.

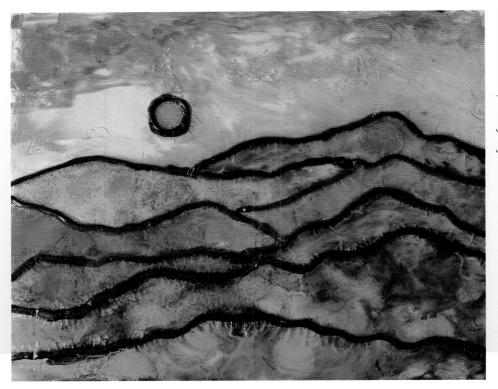

FAUX STAINED GLASS

As I was creating stained glass-like acrylic skins, I began to wonder about actually making stained glass. "What if" I made something like a skin on glass? Using faux leading from the craft store, I created a design. Then, I went from section to section, creating mini skins in each area. The results were terrific, without the work of real stained glass.

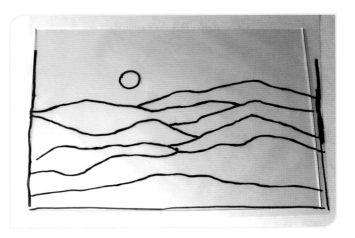

1 Place your drawing under the glass to serve as a guide.

114

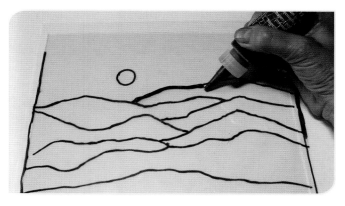

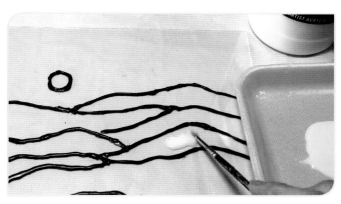

2 Squeeze faux leading around the outline. This takes a little practice, but don't worry if you make a blob. It can be scraped off with a craft knife after it dries.

3 Allow the faux leading to dry. Working in one area at a time, apply a little gloss medium and varnish into an area, and add drops of ink colors.

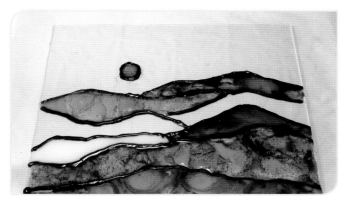

4 If desired, swirl the colors with a coffee stirrer. Move to the next area and repeat the process until the design is complete.

5 If you would like clear areas of glass, simply apply the gloss medium and varnish in random strokes with a brush. Allow to dry thoroughly.

Visit your local dollar store for inexpensive frames with glass or plexiglass. The glass will be a standard size and you may even be able to mount your work back into the frame by carefully gluing the inside ledge and placing the glass onto it.

Dover Publications has a huge line of books and CDs with archival, noncopyrighted images. You may use the images in your artwork without copyright issues.

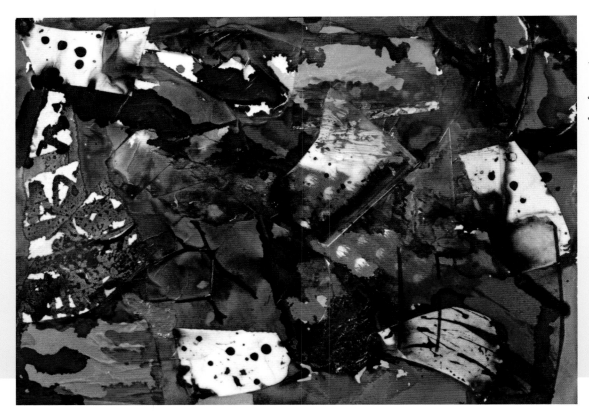

MIXED MEDIA COLLAGE

I love mixed media. I love collage. I was happy to find a way to add my new favorite medium, alcohol ink, to the mix. I create a mixed up background with odds and ends of papers and plastics, all glued down with white glue mixed with a bit of water. Building layers of different types of materials gives the collage a lot of texture and also allows the inks to be muted or shimmering depending on the substrate below. Use canvas, bristol paper, Claybord, or Yupo.

Mixed media pieces often do not lie flat when completed. I have found that applying a heavy object overnight produces a nice smooth, flat piece. I use the Cathy Car Press! Simply cover your artwork with plastic, then a clean piece of plywood. Apply your car (run a tire up on the artwork), leave overnight, and presto.... flat art!

1 On substrate, tape white artists' tape in areas. I am using Terraskin paper.

2 Using glue mixture (⅞ glue, ⅛ water), glue crinkled pieces of tissue paper over the substrate.

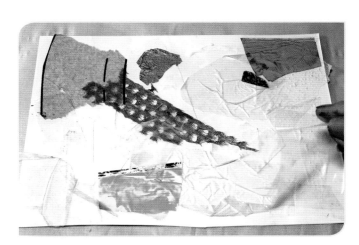

3 Continue adding pieces of cellophane, plastic wrap, foil, candy wrappers, etc. Seal everything down with the glue mixture. Allow to dry.

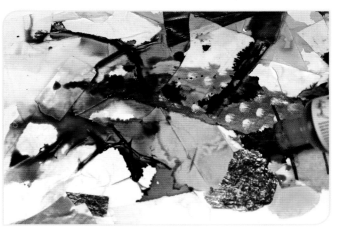

4 Drop or paint in alcohol inks. Use alcohol markers for details.

MARBLED PAPERS

Everyone knows that alcohol and water don't readily mix. This happy fact allows us to create beautiful marbled papers quickly and easily. This magical, no-hassle paper can be used for collage, greeting cards, or fabulous backgrounds for stamping and stenciling.

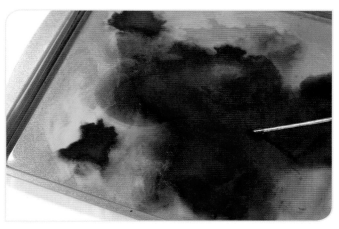

1 On flat surface, fill a cookie tray, with sides, with water.

2 Drop different colors of alcohol inks onto the surface. If desired, gently swirl with a coffee stirrer.

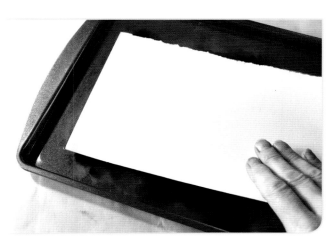

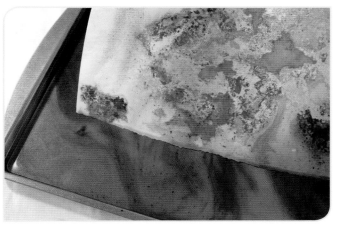

3 Place a sheet of bristol paper onto the surface and pat gently.

4 Remove bristol paper and place on a covered surface to dry. You may continue to add colors until the water becomes muddy. Then simply start again with clean water.

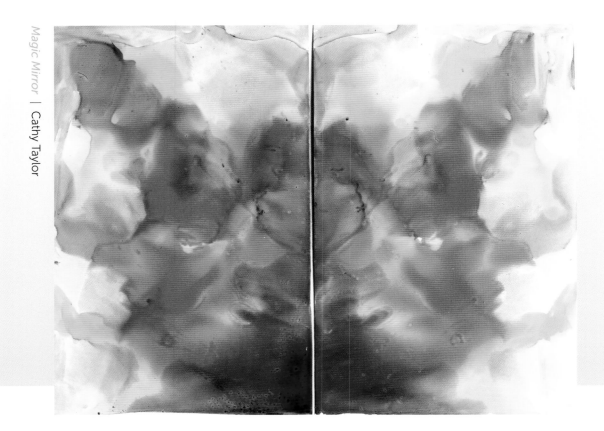

Magic Mirror | Cathy Taylor

MONOPRINTING WITH ALCOHOL INKS

Monoprinting with inks is a fun, immediate process. Sometimes the result will be a finished painting; other times the result will act as a super-spontaneous background or the first stage of a more detailed piece. Often, these pieces can be worked into with rubbing alcohol to create an image by removing ink. Or, use markers to draw a detailed image onto the colorful background.

"When my daughter was about seven years old, she asked me one day what I did at work. I told her I worked at the college; that my job was to teach people how to draw. She stared at me, incredulous, and said, 'You mean they forget?'" *-Howard Ikenoto*

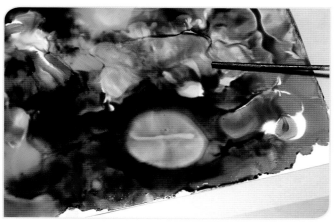

1 Using a paper towel, coat a sheet of Yupo paper with a layer of rubbing alcohol or a blending solution.

2 Drop, swirl, paint, and drag inks around the paper. Work quickly.

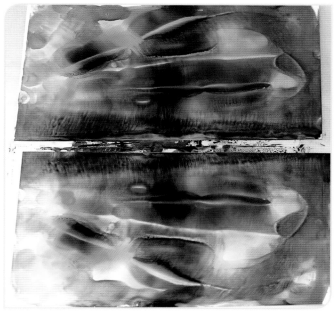

3 Immediately place another sheet of Yupo on top and press lightly.

4 Remove the top sheet. You will have two mono-prints. You may add inks to the bottom sheet and repeat if desired.

GALLERY

You now have a collection of all the techniques I have discovered to date for working with alcohol inks. I will continue to ask "what if" and search for new ways to work with this fabulous medium.

As you can see, there are dozens of ways to create with alcohol inks. Pick and chose the techniques that speak to you, the ones that lead you on a path of joy and discovery. Take the techniques that intrigue you and make them your own. Combine different methods and create a new idea. Your personality, your life experiences, and your inspiration for creating art are all unique and personal.

"Artists, like poets, create works that are distillations of rich life experiences as well as investigations of new realities."
Louise Cadillac

"There is a sacred essence in each human. This can only be realized and shared when we go beyond ourselves and reach beyond our limits."
Mary Todd Beam

I have had the opportunity to participate in workshops and classes taught by amazing, generous artists. Each of these instructors made a special impact on my journey as a fellow artist. I hope that this book will help inspire you to continue along your own unique path of artistic discovery.

Enjoy this gallery of fellow artistic explorers.

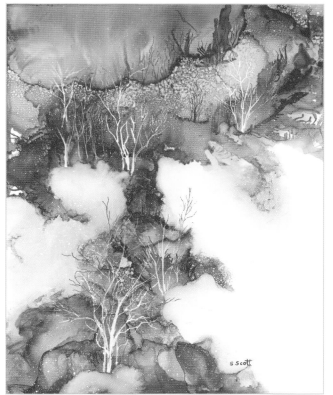

Chilly | Sandy Scott

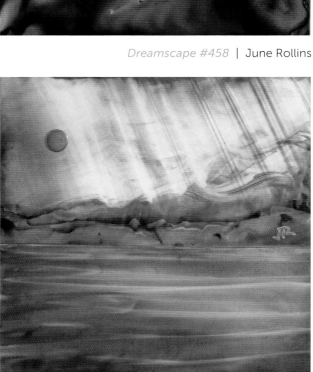

Dreamscape #458 | June Rollins

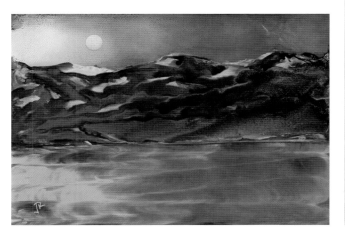

Dreamscape #433 | June Rollins

Dreamscape #463 | June Rollins

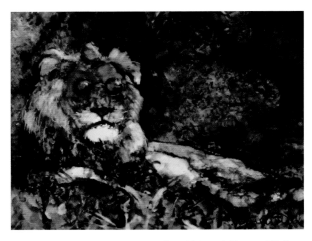

Cool Lion | Karen Walker

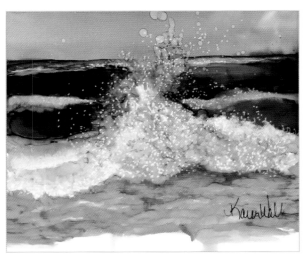

Sea Surf | Karen Walker

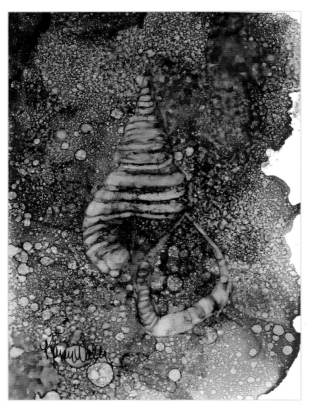

Shell Secret | Karen Walker

No. 12 | Karen Walker

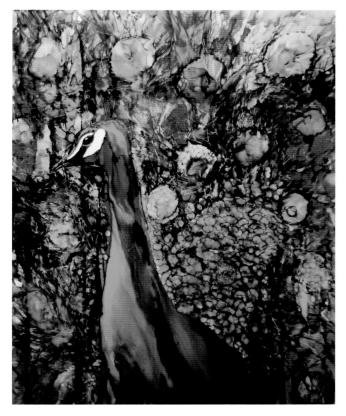

Peacock II | Karen Walker

Square du Veit Gallant | Karen Walker

Long View | Christy Alden

Rocky Mountain High | Christy Alden

Organics 103 | Ginnie Conaway

Afterglow | Maureen Sousa

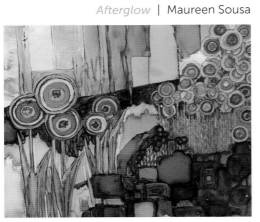

Number XIII | Vicki Barry

Number XII | Vicki Barry

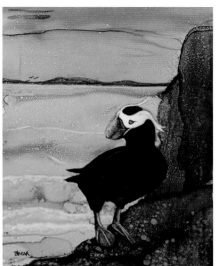

Mr. Puffin | Jill Bhear

Number VI | Vicki Barry

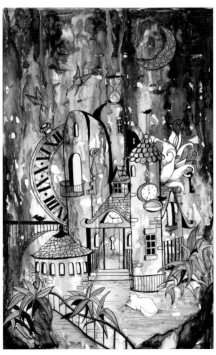

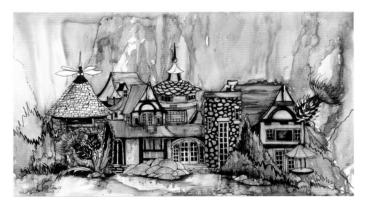

House on Thistle Downs | Billie Crain

The Timekeeper's Cottage
| Billie Crain

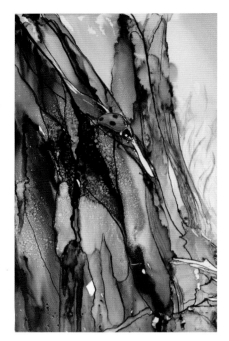

Ladybug | Billie Crain

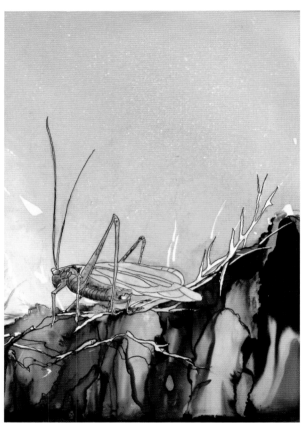

Katydid | Billie Crain

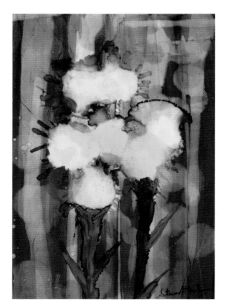

Madras Floral | Steven Newhouse

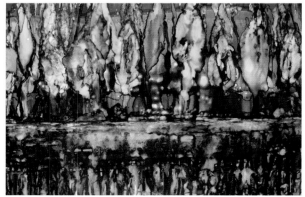

Reflection Pond | Cathy Taylor

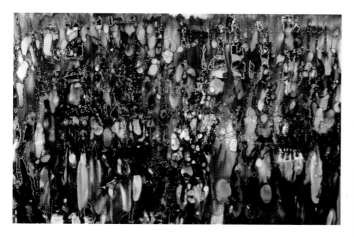

Stalagmites | Cathy Taylor

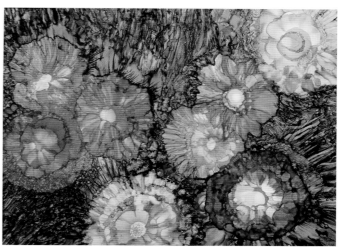

Flower Song | Cathy Taylor

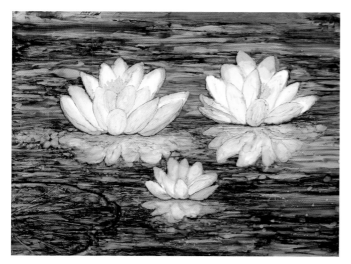

Lily Pond | Cathy Taylor

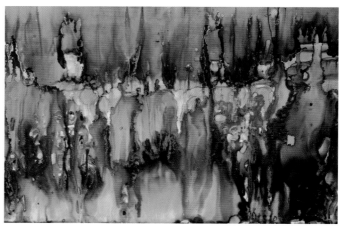

Dreaming in Blue | Cathy Taylor

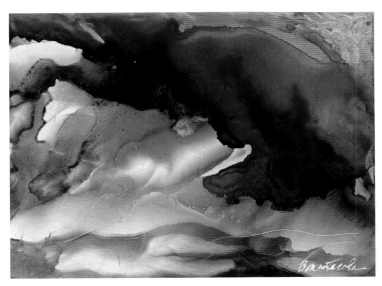

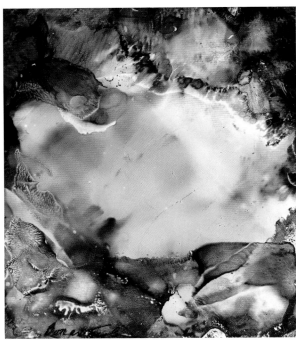

Turbulence | Alexis Bonavitacola

Sea Monsters and Treasures | Alexis Bonavitacola

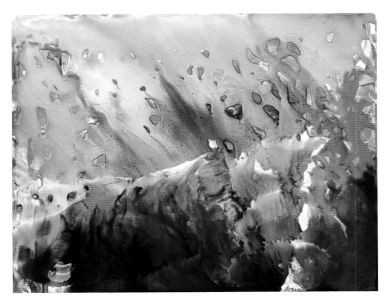

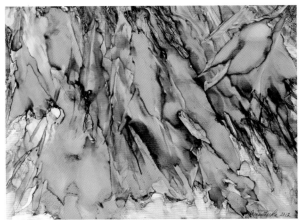

Lightening Bugs | Alexis Bonavitacola

Cascading Leaves | Alexis Bonavitacola

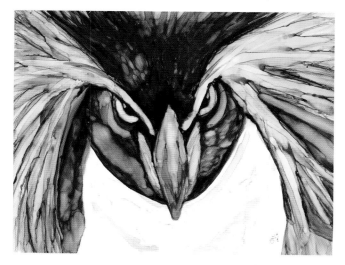

Bad Ass | Laurie Henry

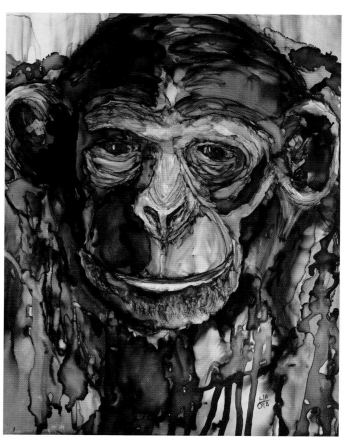

Einstein | Laurie Henry

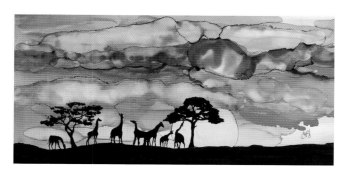

Hangin in the Serengeti | Laurie Henry

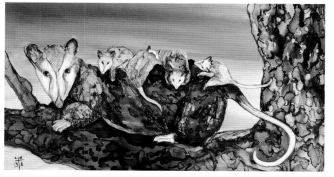

Heavy Load | Laurie Henry

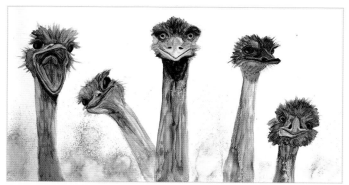

Maribel and the McTuffs | Laurie Henry

GLOSSARY

Acrylic Gel Medium: used for building texture or as an adhesive. Composed of 100% acrylic polymer, gel medium is flexible, water- and UV-resistant.

Acrylic Gloss Medium and Varnish: 100% acrylic polymer medium that is durable and dries to a clear, glossy protective surface. It is a self-leveling medium that may be used to create colorful skins.

Acrylic Skin: dried acrylic medium tinted with color; skins may be used in collage or layered artwork.

Analogous color: colors that are next to each other on the color wheel, such as blue and purple.

Batik: cloth that is made using a wax resist dyeing technique.

Bristol Paper: acid-free, machine-finished paper. The surface texture is plate, which is very smooth, or vellum, which is textured. Use the plate finish when working with alcohol inks.

Canned air: compressed air used to clean dust and lint from keyboards, dashboards, and other surfaces. Use ozone safe.

Claybord: panel coated with a very smooth clay ground. Archival and acid free.

Craft Foam: thin foam sheets used for craft applications.

Disposable Syringe: plastic medical syringe available at pharmacies without needle.

Faux Stained-Glass Leading: water-based, nontoxic polymer medium used to simulate leading. Available in two-fluid-ounce bottles with applicator tip.

Fiber Paste: acrylic polymer medium with the appearance of rough paper when dry.

Hake Brush: soft, inexpensive flat brush available in many sizes.

India Ink: composed of fine soot (lampblack) combined with water and a binder such as gelatin.

Krylon Triple Thick Crystal Clear Glaze: durable, flexible protective glaze. Bright, clear, high-gloss finish.

Laminate: clear plastic protective covering. Purchase in sheets or rolls at office supply stores.

Madras: a fine cotton or silk fabric of bright colors usually with woven stripes.

Masking Fluid: removable, colorless liquid used to protect white or under-painted areas.

Oiler Boiler: small plastic bottle with a needle tip. When filled with pigment, alcohol, or even masking fluid, it will create fine detail.

Piñata Claro: may be used with alcohol ink to extend drying time. Also used to create texture or lighten areas by moving ink. Available in one- and four-ounce bottles.

Polymer: natural or synthetic substances including polyethylene, nylon, and some plastics.

Porous: surface permeable to fluids.

Ranger Blending Solution: acid-free formula used to dilute or lighten alcohol inks. Precision-tip bottle.

Rubbing Alcohol: denatured alcohol available in different percentages by volume, either isopropol or ethyl. When working with alcohol inks, 91% isopropol alcohol is used. Note, rubbing alcohol should be used in a well-ventilated area.

Substrate: any surface on which a process occurs. For artwork, this includes canvas, paper, plastic, wood, and more.

Tar Gel: acrylic polymer medium with a stringy consistency. Use for doodling fine lines for texture and pattern.

Terraskin Mineral Paper: Earth-friendly paper made from rocks, using no water. Water resistant, strong, durable, acid free, and fiberless, Terraskin does not absorb like paper.

Variegated Wash: a wash using more than one color.

Wash: pigment laid over an area too large to be covered in one brushstroke.

Wet into Wet: layers of pigment applied to previous layers of wet pigment.

Yupo Paper: synthetic paper that is 100% recyclable, waterproof, and tree free. Super smooth and durable, it does not tear. Made in the USA; ph neutral. Available in sheets or pads.

RESOURCES

Art Supplies

aftosa.com

amazon.com

artisticartifacts.com

bluetwigstudio.com

cheapjoes.com

citrasolv.com

constrvct.com

copicmarker.com

danielsmith.com

dickblick.com

doverpublications.com

fiskars.com

jacquardproducts.com

jerrysartarama.com

joann.com

michaels.com

myblendall.com

rangerink.com

scrapbooking-warehouse.com

stencilgirlproducts.com

spectrumnoir.com

utrechtart.com

Art Retreats and Workshops

adventuresinitaly.net

artandsoulretreat.com

artunraveled.com

artworkshops.com

art-xscape.com

bigarts.org

cheapjoes.com

createmixedmediaretreat.com

dillmans.com

europeanpapers.com

floridaartistworkshops.com

folkschool.org

Art Organizations

iseaartexhibit.org

nationalcollage.com

GUEST ARTISTS

CHRISTY ALDEN is an accomplished pastel artist new to the wonders of alcohol ink. Her paintings are inspired by the diversity of Colorado's landscapes, from the vast openness of the prairies to the rugged terrain of the Rockies. Her work has received awards in regional and national exhibitions. She teaches classes for adults and children in her studio in Fort Collins, Colorado. Contact Christy at c2alden@hotmail.com.

VICKI BARRY comes from a family populated with very talented, creative people. Though she has no formal art training, she credits her artfulness to many incredible high-school art teachers. She discovered alcohol ink in the spring of 2012. Since then, she has received awards and conducted workshops sharing with others the joy of creating with alcohol inks. Vicki lives an artful life in Eureka, California, with her husband, David, two daughters, two dogs, and a cockatiel. For more information go to vicki-barry.artistwebsites.com.

JILL BHEAR discovered her love for art in her late forties and hasn't stopped painting since. She continued to learn about different media and liked painting with acrylics until she discovered alcohol inks in 2013. She was hooked. Jill loves the vibrant colors and wonderful surprises that occur when creating with alcohol inks. A grandmother living near Seattle, Washington, she believes you are never too old to try new things.

ALEXIS BONAVITACOLA is a passionate educational administrator for public schools. She recently discovered the beauty of alcohol inks and finds that creating with them unlocks her artistic spirit. As she researches and writes for her PhD, she finds that the inks give her the opportunity to play outside the box. For more go to fineartamerica.com/profiles/alexis-bonavitacola.html.

GINNIE CONAWAY'S painting time is supervised by four dogs who are very tough critics and wish for more plein air painting time. Years of painting commissioned portraits of pets and people led her to a rather tight painting style, which did not leave much room for play. Enter alcohol inks. Ginnie regained her sense of discovery. Ginnie teaches classes in alcohol inks where she teaches her students to relax, enjoy and go with the flow. See her art at http://ginnieconaway.net.

BILLIE CRAIN is a self-taught artist from Charlevoix, Michigan. She has always loved art but began pursuing her work seriously in 2005. She is represented by Northern Michigan Artists Market in Petoskey, Michigan. Billie was introduced to alcohol ink painting in 2012 and was immediately smitten. She developed the faux batik on waxed paper to satisfy her inner control freak. Visit her at http://artbycrain.blogspot.com.

LAURIE HENRY began her artist adventure with watercolors in 2009. In 2013, Laurie discovered alcohol inks and instantly fell in love with their unusual behavior and incredible vibrancy. Laurie, MISD teacher of the year in 2006, founded the company Trinity Science Solutions that presents science classes all over Texas using huge inflatable models. She enjoys camping, canoeing, and feeding the critters in her backyard. She is married to her high-school sweetheart Joe, and has two grown sons, Cody and Cory. See her art at ragamuffinexpressions.com.

DIANE MARCOTTE is a self-taught artist who began painting in oils forty years ago. She lives in Oakville, Ontario, with her husband and three sons. After a career in banking, she began painting in earnest. She was drawn to alcohol inks for their vibrancy and jewel-like tones.

Her goal is to reveal the spirit of nature so that all can enjoy. See her art at fineartamerica.com/profiles/1-diane-marcotte.html.

STEVE NEWHOUSE is retired and lives in Boone, North Carolina, after a forty-three-year career in human resources management. He has enjoyed painting in watercolor for the last fifteen years. His new-found interest in alcohol inks has expanded his artistic endeavors. Steve serves on the board of directors of the Watercolor Society of North Carolina and is responsible for long-range planning.

JUNE ROLLINS, author of *Alcohol Ink Dreamscaping Quick Reference Guide* and producer of five *Dreamscaping with June Rollins®* DVDs, founded Alcohol Ink Art Facebook Group in 2012. She is a signature member of the Watercolor Society of North Carolina and the Southern Watercolor Society. For more information, go to www.junerollins.com.

SANDY SCOTT is primarily a self-taught artist who began her art journey in oils and later added watercolors, acrylics, and, of course, alcohol inks to her repertoire. She lives with her husband and family in Sanford, North Carolina, where she has explored the scenes of the Smoky Mountains, the Crystal Coast, and the endless variety of floral and fauna of the area. Reach her at sscottartist@yahoo.com.

MAUREEN SOUSA, resident of Tewsbury, Massachusetts, has pursued creative expression in many forms from an early age. She was the supervisor of the glazing department at Dedham Pottery Reproductions and an artist assistant for Katherine Houston Porcelain. Wanting to be a part of the eco-conscious movement, she found another passion using alcohol ink on eco-friendly paper. She has six grandchildren who are learning the importance of art and creating in their lives. Contact Maureen at willowtree23@msn.com.

KAREN WALKER is an artist and instructor working in the Sandhills area of North Carolina. With a background in art history and painting in oils and pastels, she has discovered the joy and passion of working with alcohol inks. The vibrant color and fluidity of the inks have brought spontaneity and excitement to her representational paintings. Information regarding her online classes and artwork at www.karenwalkerart.com.

WENDY WILKINS is a true renaissance woman. She has one hand in the art world and the other in business. She earned a degree in economics at UCLA and an MBA at the University of North Carolina at Chapel Hill. As an artist, her goal is simple: to bring a smile to the viewer's face. Wendy finds inpiration in the natural world and believes alcohol inks' vibrant colors and abstract tendencies are the perfect way to demonstrate the beauty and emotion that nature evokes. She resides in North Carolina and relaxes by drinking lattes, reading, or escaping to the mountains. See her artwork at fineartamerica.com/profiles/wendy-wilkins.html.

ACKNOWLEDGMENTS

Thank you to Sandy Scott for her fabulous discovery, and to June Rollins and Karen Walker for creating the alcohol ink group, a place for show and tell and artistic sharing. Many thanks to the folks at Schiffer Publishing for the freedom to create the book I imagined and the guidance to achieve that goal. I am also grateful for all the workshop instructors and incredible artists who were so generous in sharing their knowledge and encouragement to bring me to this happy place in my life.

ABOUT THE AUTHOR

CATHY TAYLOR is an award-winning mixed media artist and popular workshop instructor. Her artwork is a celebration of the patterns, textures, and color found in the natural environment. Cathy is known for her ability to interpret a subject in a variety of styles. From her colorful, detailed alphabetical designs, including the Florida shell alphabet, to her whimsical collages and multidimensional abstracts, Cathy's work is represented in galleries, museums, nature centers, and private collections throughout the U.S. and abroad. Cathy's articles have appeared in *Cloth, Paper, Scissors* magazine. She is a featured artist on artacademylive.com and Cheap Joe's Art Stuff YouTube Page. She has created two DVDs: *Watercolor Collage* and *Mixed Media Collage*. Cathy is a signature member of the International Society of Experimental Artists and a signature member of the National Collage Society. Cathy lives in the foothills of the Blue Ridge Mountains with her husband, Scott, lots of wild critters, and their two "Doodles," Elle and Gracie May.